PEGASUS
Library

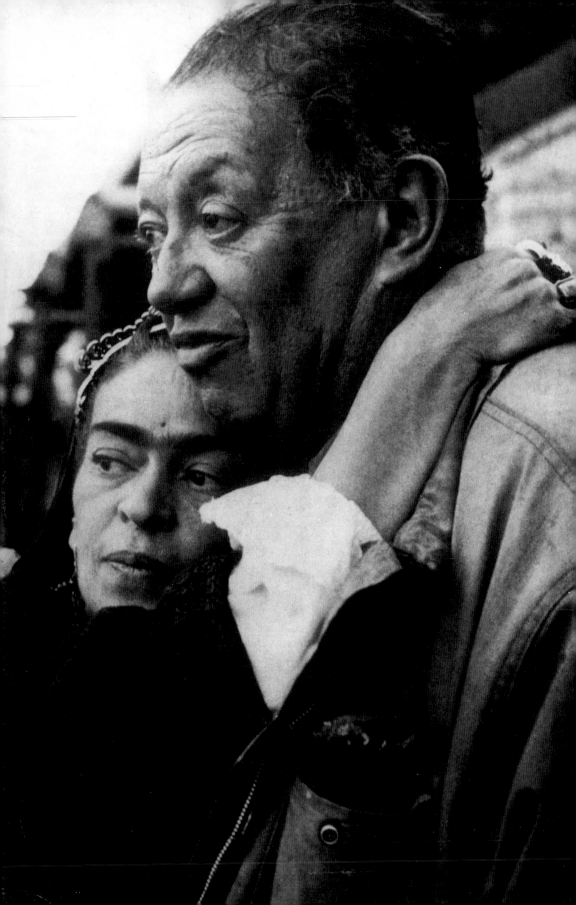

Isabel Alcántara
and Sandra Egnolff

Frida Kahlo
and
Diego Rivera

Prestel Munich · London · New York

Childhood years in the Blue House

We shall probably never learn the whole truth about Frida Kahlo and Diego Rivera. Too many versions of too many tales have been told about them. Diego Rivera always saw to it that a lush growth of legends sprang up around him. Frida Kahlo enjoyed embroidering her past and veiling it in mystery every bit as much as he did. Frida's fictions start with her year of birth. She claimed to have been born in 1910, the year of reform, fierce fighting and liberation, the year of revolution, when, led by Emiliano Zapata and Francisco 'Pancho' Villa, Mexico rose up against the Diáz regime. She wanted to feel that the ideals of the revolution were born with her. However, Frida was really born on 6 July 1907.

Magdalena Carmen Frida Kahlo Calderón was born in the Blue House in Coyoacán, a pretty southern suburb of Mexico City. For many years Frida Kahlo lived there with Diego Rivera. The house is on one floor, U-shaped, with blue-washed walls, high windows, green shutters and an inner courtyard full of subtropical plants. Frida introduced her house to the world in 1936 in the painting entitled *My Grandparents, My Parents and I* (see p. 9). In it, she has portrayed herself as a naked little girl, standing in the courtyard with a red book in her hand, which links her with her parents and grandparents like a record of a family tree. Her father built the Blue House in 1904 on a piece of property which had once belonged to the 'El Carmen' hacienda. After Frida Kahlo's death, Diego Rivera had the house enlarged and turned into

opposite page:
"Pinté de 1916".
The first illustration in the diary which Frida Kahlo kept from 1946–54
Diego Rivera and Frida Kahlo Museum, Mexico City

right:
Wedding photograph of Guillermo Kahlo and Matilde Calderón, 1898

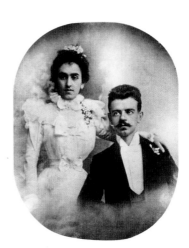

a museum. Today it draws visitors from all over the world. Frida's exotically decorated four-poster bed, in the wardrobe the Tehuana dress she loved to wear, her easel and palette in her studio, the rustic kitchen with the names Frida and Diego immortalized on the wall, all make us expect the owners to walk in at any minute.

Frida's father, Wilhelm Kahlo, was born in Baden-Baden, Germany, and was a Jew of Hungarian extraction. In 1891 he went to Mexico. When the youthful adventurer arrived there, he neither spoke the language nor possessed more than the clothes he stood up in. Nevertheless, it wasn't long before his social and financial position was secure enough to allow him to change his first name to Guillermo and, in 1894, to marry a Mexican woman. She died in childbirth when her second daughter was born.

Guillermo soon fell in love again. Frida describes her father's remarriage as follows: 'During the night his wife died, my father called in Isabel, who was to become my grandmother. She arrived with her daughter, who was working in the same business as my father. He fell head-over-heels in love with her and later married her.'[1]

The young girl who had turned Guillermo Kahlo's head was Matilde Calderón. Her maternal grandfather was a Spanish general of Indian descent. Matilde, a very devout Catholic and pious to the point of bigotry, demanded that her husband send his two daughters from his first marriage to a convent. Guillermo Kahlo acquiesced in her wish and he also agreed to become a photographer, like Matilde's father. As an immigrant, he had an especially observant eye for the beauties of the country, which he saw, as it were, as an outsider looking in. Between 1904 and 1908, as official government photographer, he accompanied Porfirio Díaz, the dictatorial President of Mexico, on numerous trips throughout Mexico. Kahlo earned enough money to build the Blue House for his family and even to send his daughters to a German school. Unfortunately for Guillermo Kahlo, the forced resignation of Díaz in 1911 also put paid to financial security. In his last years, the support of his

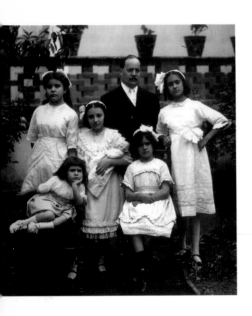

Frida Kahlo, aged 5, with her relatives, including her two sisters, Matilde (back row, on left), and Adriana (front row, on right). Photograph taken by Guillermo Kahlo, in Coyoacán, in 1912
Photo: Cristina Kahlo, Mexico City

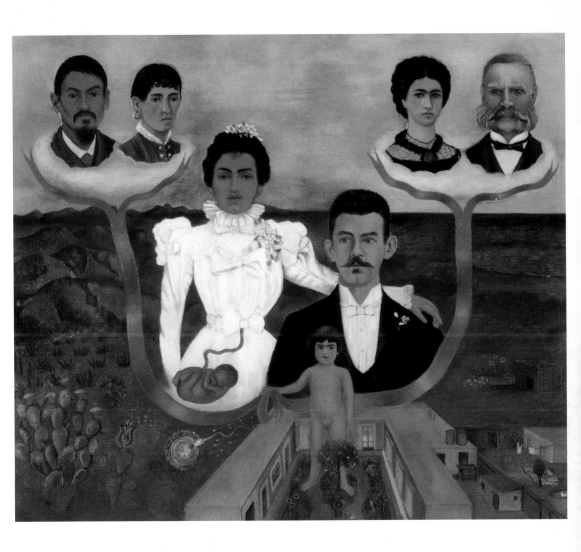

My Grandparents, My Parents and I
1936
Oil and tempera on metal
31 x 34 cm
The Museum of Modern Art, New York.
Gift of Allan Roos. M.D. and B. Matheu Roos

son-in-law, Diego Rivera, was all that kept him in the Blue
House.

Frida, Guillermo Kahlo's third daughter, was a particularly
lively and cheeky child. She was certainly her father's
favourite daughter. 'Frida is my most intelligent daughter,'
he used to boast with pride, 'she's most like me.'[2] Frida in
turn lavished affection on him, returning his love with what
can only be termed veneration.

Only eleven months after Frida's birth, her sister Cristina
was born. Their mother, left weak and ailing by two births

in such rapid succession, hired an Indian nurse for Frida. Nonetheless, although Frida may not have had as much mother love as she should have had in the first years of her life, her early childhood was a happy one. What she lacked in attention from her mother was more than made up for by her father's affection.

This secure and happy childhood lasted all of six years. Frida had polio and the disease left her right leg deformed. She suffered excruciating pain and was confined to her bed for nine months. Although her distraught father insisted that she swam regularly, rode a bicycle until she was ready to drop from exhaustion and engaged in all sorts of other sports, her right leg remained thinner than her left. For the rest of her life, Frida took care to hide her withered leg under long skirts.

Thus, when she was only six years old, began the cycle of isolation and loneliness caused by physical suffering that was to haunt Frido Kahlo as long as she lived. At the German school she was taunted by her schoolmates, who called her 'pata de palo', 'gammy leg', and made her life miserable. Frida, who was always too proud and defiant to show others that they had hurt her, sought refuge in her imagination. There she was accepted for what she was. The artist had this to say about her double self-portrait, *The Two Fridas* of 1939 (see p. 68):

'I must have been about six years old when I started vividly picturing to myself a friendship with another girl of about my own age. I used to blow on the window of my room, which gave onto Allende Street, and draw a door on the pane. I imagined that I then ran, full of excited anticipation, out through this "door", and crossed the vast "plain" which I saw in my mind's eye stretching out before me until I reached the "Pinzón" (Finch) dairy. There I slipped through the "ó" in Pinzón and immediately plunged into the bowels of the earth, where the playmate of my dreams awaited me. I no longer remember her form and colouring but I do know that she was a lot of fun and laughed a great deal, soundlessly, of course.

She was very nimble and could dance (...) When I returned to my window from my imaginary excursion, I came back through the "door"; then I rubbed it out quickly with my fingers to make it disappear.'[3]

Frida and her sisters were brought up in the Catholic faith. Although there is no denying a religious component in Kahlo's work, Matilde's bigotry was definitely one of the reasons for Frida's ambivalent feelings about her mother. 'My mother was excessively religious,' Frida used to say. 'We said grace before every meal and, while the others were concentrating on their inner selves, Christ and I would just look at one another and choke back our laughter.'[4]

Frida — a rebel from the start

In 1922 — Diego Rivera was already 22 years old and a famous painter — Guillermo Kahlo decided to send his cleverest daughter to the 'Escuela National', an excellent 'preparatoria' or college preparing for university entrance. Frida's mother opposed this plan because the school was near the Zócalo, the centre of Mexico City, and, therefore, miles from home. Besides, she was appalled at the thought of her daughter attending a co-educational school, something that was highly unusual in those days. There were only about five girls to three hundred boys at the school and Matilde was outraged at the thought that one of them was to be her daughter. The Kahlos finally agreed to allow Frida to enrol for the entrance examination and she passed it with flying colours. From now on she was a matriculated student at the 'prepa', among the most privileged of young Mexicans, and planned to study medicine.

All the taunts she had had to put up with because of her deformed leg had made Frida a defiant, rebellious and tough teenager. She was totally different from the other girls in her class. Even then she made a point of not dressing like everyone else. Whereas the other girls were just beginning to flaunt their feminine charms, Frida wore her hair severely parted and pulled back. She dressed austerely

pages 12–13:

Frida Kahlo (centre) loved to dress up in men's clothing when she was a little girl. This picture, taken by her father, Guillermo Kahlo in 1926, shows her with her mother and sister, Cristina.
Photo: Archivo CENEDIAP-INBA, Mexico City

in a blue pleated skirt with white blouse and tie, like the uniform worn by the girls at the German school, and often appeared for family photos in men's clothes. She invented her own personal slang, 'fridesco', and often shocked people by using vulgar and coarse language.

Quite a few pupils at the 'prepa' were remarkably intellectual and had revolutionary ideas. Frida, who despised most of the girls at the school, calling them 'escuinclas', Mexican hairless dogs, soon joined a group of overwhelmingly male student intellectuals called 'Los Cachuchas'. They met in the Ibero-American library and were notorious for vehement discussions on Hegel, Marx and Engels as well as malicious practical jokes. The group comprised seven boys and two girls: Alejandro Gómez Arias, Miguel N. Lira, Jesús Ríos y Valles, José Gómez Robleda, Manuel González Ramirez, Alfonso Villa, Augustín Lira, Frida Kahlo and Carmen Jaime. Alejandro Gómez Arias was the leader of the group, a charismatic and talented orator, who later became a respected lawyer and political journalist and was to play a significant role in Frida Kahlo's life. Miguel N. Lira, who was already at university, had a penchant for Chinese poetry, which is why his friends called him Chong Lee. He wrote plays and published several journals in addition to writing poetry in his spare time. He remained a friend of Frida's all his life, supporting her with numerous newspaper articles on her work. José Gómez Robleda, who enjoyed crocheting, made the 'cachuchas', the caps from which the group's name derived. He was to lead a rather lonely, sad life as a professor of psychiatry, devoting his spare moments to music and mathematics. Manuel González Ramires was another member of the group who would remain in touch with Frida all his life. He read law and was Frida's lawyer when she divorced Diego. Carmen Jaime, the only other girl besides Frida in the 'Cachuchas', later read literature at university. She was a strange, reticent person and her peculiar way of speaking exerted a strong influence on Frida.

The practical jokes played by the 'Cachuchas' were greatly feared. The story goes that they once tied a cracker to a

dog and then drove the terrified animal through the 'prepa'. Frida often found school so boring that she either played truant or disturbed lessons to the consternation of her teachers. From time to time she approached the headmaster with the petulant demand that he sack some teacher or other who wasn't up to his job. The 'Cachuchas' even had the nerve to molest well-known artists who had been commissioned by the minister for education, Vasconcelos, to paint murals on the walls of the 'preparatoria'. On one occasion the 'Cachuchas' burnt down the mural painters' high scaffold and the murals were destroyed in the blaze. One of their prime targets was Diego Rivera. After years spent in Europe, he had returned to Mexico and had been commissioned to execute the frescoes in the Bolivar Amphitheatre of the 'prepa'. This is where Frida first met her future husband. She was only fifteen at the time.

Rivera, who already enjoyed a great deal of popularity in Europe, was regarded at the 'prepa' as a feather in the school's cap. Long since used to gazing down on crowds of rubbernecking onlookers from the lofty heights of his scaffold, he was quite obviously fascinating to women when he was on the ground. He certainly didn't look attractive: he was fat and pop-eyed, with greasy hair. His clothes were invariably dirty and rumpled. When Frida heard that the artist was working at her school, she immediately set to work thinking up ways of making his life hideous. She soaped the steps up which Rivera walked on his way to work and spied on him unseen, hoping to catch sight of the Master in the act of slipping on her handiwork. To her dismay, the easy-going fat man remained serenely unaware that he was on a slippery slope. The following day, a much thinner man, a schoolmaster, fell victim to Frida's practical joke.

Whenever the mural painter was accompanied by the woman he lived with, Lupe Marín, Frida would call out: 'Watch your step, Diego, Nahui's coming!' That was the name of another woman he was having a secret affair with, who of course was nowhere near.

One day Frida decided to watch Rivera at work. Although she hardly moved, said nothing and was so far away, her wild beauty, her youth and her clear gaze seemed to dominate the room. Lupe Marín, who was there that day, was made increasingly nervous and jealous by the girl's disturbing presence. She attacked Frida like a Fury, demanding that she leave the room, but Frida didn't budge.

'A year later I heard that it was she who was hidden behind the columns and called out and that her name was Frida Kahlo,' Diego Rivera related. 'Yet I could never have dreamt then that she would one day be my wife.'[5]

Frida, on the other hand, was already observing to the other girls at school that she wanted to have a child by that man one day and that she would let him know when the time was ripe.

First brush with death

It happened on 17 December 1925, the day after Mexico became independent. A lot had changed in Frida Kahlo's life. She was no longer alone because she now had a *novio*, a boyfriend, Alejandro Gómez Arias no less, the leader of the 'Cachuchas'. As a proof of her love for Alejandro, she painted a handsome but rather melancholy portrait of him three years later. It was not rediscovered until 1994. Frida and Alejandro were sure they were made for each other and forged plans for the future.

That day, 17 December 1925, they both got on one of the buses which had started only a short time before to serve the city. They were wooden buses with long benches down each side and their drivers were inexperienced. Frida and Alejandro had been on a different bus but, while on it, Frida had missed a little toy parasol. Because toys meant a lot to her, she left the bus to look for the parasol. Her search was fruitless and she bought another toy. And that is how she came to be sitting on the fateful bus that was

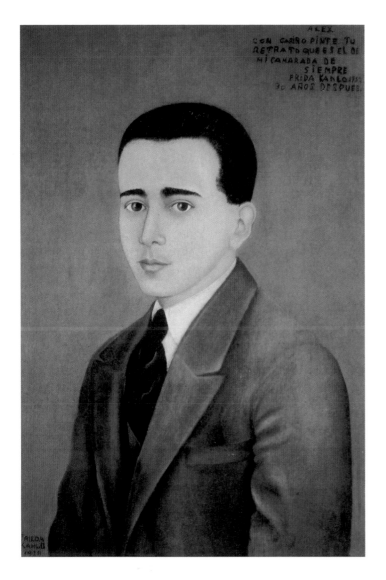

to leave its mark for ever on her life. The bus crashed into a tram. Before the wooden bus collapsed, it buckled so ominously that the knees of passengers sitting across the aisle from each other touched. Frida, who was not at first aware of what had happened, thought only of retrieving the second toy she had lost that day but was unable to do anything. There she lay like a broken china doll, covered with blood and gold dust which apparently another passenger had been carrying. Frida heard someone shout 'La bailarinita, la bailarinita!' Her fellow-passengers thought this pale creature dusted with gold was a ballerina. Alejandro, who had remained virtually unharmed, wanted to help Frida up, when he was horrifed to see that a rod which passengers normally hung on to had pierced Frida's body. A passenger was able to pull it out and Alejandro laid the girl on the billiard table of a nearby saloon until help arrived. Finally the ambulance came to take Frida to the Red Cross Hospital. She was found to have eleven fractures of the right leg, her right foot had been dislocated and crushed, her left shoulder was dislocated and her spine and pelvis were injured. Her collar-bone, two ribs and the pubic bone were all broken. The iron rod had skewered her left hip to stick out through her vagina.

Porträt Alejandro Gómez Arias 1928
Oil on canvas (?)
Bequest of Alejandro Gómez Arias, Mexico City

Her family was immediately notified of the accident. There was very little hope that the girl would live. Frida Kahlo recalled:

'Matilde [Frida's eldest sister] read the news in the paper. She was the first to come to me and she never left my side for three months. My mother was struck dumb for a month from shock and didn't visit me once. My sister Adriana fainted when she heard about it. My father was so sad

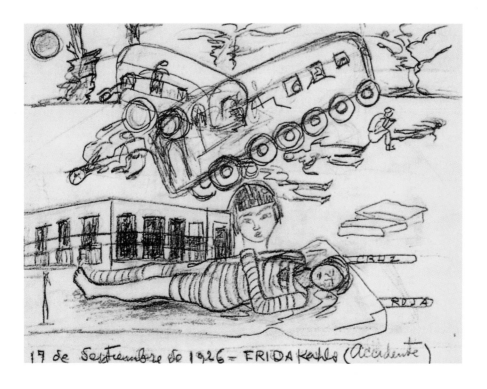

17 de Septiembre de 1926 — FRIDA Kahlo (accidente)

Accident 1926
Pencil on paper, 20 x 27 cm
Coronel Collection, Cuernavaca / Morelos

that he became ill and was not able to visit me until twenty days had passed.'[6]

While in hospital, Frida often saw Death dancing about her bed. She was not out of danger for quite some time and her back and right leg hurt agonizingly the whole time. After a month in hospital, Frida was sent home but her life had irrevocably changed. She could no longer go to school and her friends rarely visited her since Coyoacán was too

far from the centre of town. Frida spent all day lying in bed and was often unable even to sit up. She kept writing letters to Alejandro, who was imperceptibly growing away from her:

20 October 1925: 'You can't imagine how my arm hurts. Every time they pull it, I weep a gallon of tears although the saying goes that you shouldn't believe a limping dog or a weeping woman.'

5 December 1925: 'The only good thing is that I'm beginning to get used to suffering.'

10 January 1927: 'I'm in a bad way, as usual. It's so boring, I don't know what to do because this has been going on for a year now and I'm fed up with the whole thing (...). I'm *buten, buten*[7] bored!!!

2 April 1927: 'The old doctor said to me that a tight-fitting corset might help, would be worth trying, otherwise I'm done for. On Monday I'm to be fitted for it in the French hospital. (...) The only good side of this instrument of torture is that I'll be able to walk again but, since my leg will hurt terribly when I walk, there won't be anything good about it after all. Besides, I won't be able to go out in the street in a brace like that or they'd have me locked up in the loony-bin straight off. (...) I'm sick of it all, with an S like sigh, sigh, sigh!'

25 April 1927: 'Yesterday I felt so wretched and I was so sad. You can't imagine how this illness is driving me to despair, it's unspeakable, terrible torture.'

30 April 1927: 'They fitted me for the plaster cast on Friday and since then I've been suffering sheer martyrdom; I'm suffocating, my lungs and my whole back are in agony, I can't move my leg and I can hardly walk any more and sleep even less. Can you imagine that they hung me up by my head and afterwards I had to stand for over an hour on tiptoe while it was being dried with hot air (...). I'll have to stand this torture for three or four months and

if it doesn't help, I really do want to die, for I can't take any more.'[8]

In 1927 Alejandro went to Europe. Evidently this was his parents' idea because they wanted to detach their son from Frida, who seemed at death's door. By June 1928, there was nothing left between them.

During this terrible time of loneliness, immobility and bitterness, Frida's mother had the idea of fastening a mirror to her daughter's four-poster bed and providing her with painting materials. Frida, who certainly had not attracted notice as a budding artist at school, began to develop her great talent at this lowest point of her life. She began to study art history, devouring books for hours on end, and started painting portraits of her sisters and friends. Between 1926 and 1928 alone, she executed over a dozen paintings, among them her first important work, *Self-Portrait in a Velvet Dress* (see front cover). Like others of her early paintings, this one revealed unmistakable links with Italian Renaissance art. She gave it to Alejandro, calling it her little Botticelli. The attenuated neck of the subject recalls the work of Modigliani and a graceful and highly-stylized hand is reaching out to the spectator. Perhaps this is a gesture of reconciliation with Alejandro. Her body looks fragile and pale against a blue-black ground, yet her pose and glance reveal her inner strength.

What is remarkable is that Frida Kahlo never painted the accident. All that records in her idiom the accident which she would never come to terms with is a pencil drawing, executed in 1926, nervy and coarse of line. There is also a small, real devotional image which Frida found and slightly modified.

Diego Rivera

Frida Kahlo did not develop her creative talents and prowess as an artist until she was 19 years old, and she had to teach herself everything. Diego Rivera's talent,

by contrast, had been recognized and promoted while he was still very young. José Diego María and his twin brother, José Carlos María, were born to María and Diego Rivera on 8 December 1886 in the Mexican city of Guanajuato. Since María Rivera had already had three miscarriages, the Riveras were overjoyed at the birth of twins. When Diego's twin brother Carlos died at the age eighteen months, the Riveras feared that the same fate awaited the only son they had left. With great reluctance, they finally decided to place Diego — and here his story resembles Frida's — in the care of an Indian nurse. Antonia, who lived in the country, nursed Diego at her breast and let a goat suckle him, as Rivera tells in his autobiography, *My Art, My Life.*[9] He writes that, from his second to his fourth year of life, he had both an Indio and a goat mother in addition to his own. The thin, sickly child grew into a big, sturdy boy. When Diego was three, his sister María was born and it was not long before the Riveras were once again reunited as a 'real' family.

Rivera's father and mother were both teachers. They taught their son to read at four. Later he did brilliantly at school; his academic performance was exceptional in every respect. By the time he was ten, he was taking evening art classes at the Academia de San Carlos. Two years later, he devoted himself entirely to art. One of his teachers was the landscape painter José María Velasco, whose influence is noticeable in Rivera's early work. In 1906 Rivera was awarded a scholarship that paid for a trip to Europe. In 1907 and 1908 he travelled through Spain, studying Spanish Realism and living with the paintings of Goya, El Greco, Velázquez, Brueghel, Cranach, Hieronymus Bosch and the Flemish and Italian masters in the Prado. This was a period of experimentation, of trying out different styles. Rivera began to associate with artists. However, he viewed the work he did while in Spain as representing his most trivial period.

In 1909 he went to France, Belgium, Holland and England. In Brussels he met the Russian painter Angelina Beloff. He married her and spent ten years with her in Paris, to any

woman. Angelina Beloff bore him his first son, Diego. Since the Riveras had to bring up their child in the grim poverty that was usual among artists, the child died of flu when he was only two years old, weakened by cold and hunger. The only record Rivera has left of his son is the Cubist painting *Motherhood — Angelina and our Child Diego* (1916). The work is remarkable for brilliance of colour, so typical of Diego yet rare in Cubism.

From 1913 until 1918 Rivera made a name for himself in the Cubist movement, producing excellent work like *Portrait of Zinoviev the Painter* (1913) and *Zapatista Landscape — The Guerrillero* (1915) (see p. 24). He made friends with Picasso, the supreme master of this genre, and Picasso came out strongly in favour of Diego Rivera's work. Rivera spent twelve years in Paris, never leaving it except for short trips to Mexico, Spain and Italy. By 1921 he was finally ready to go home to Mexico. He left behind his wife Angelina and his daughter Marika (born of a stormy affair with Marevna Vorobiev-Stebelska, a Russian), whose existence he was to ignore for the rest of his life.

Rivera's return to Mexico made him find his own pictorial language. Overwhelmed by the beauty and cultural richness of his country, which, from long absence, he had learnt to view with entirely different eyes, he now attained natural- ness and lightness of attack just as if he had never painted in any other manner. Diego himself said: 'My style was born like a child, in an instant, with the difference that this birth took place after 35 agonizing years of pregnancy.'[10]

José Vasconcelos summoned Rivera and other mural painters, among them Orozco and Siqueiros, to take part in the official cultural programme backed by the govern- ment. Rivera was invited to Yucatán, where he became familiar with ancient Mexican culture and the archaeologi- cal treasures that were its splendid legacy. Vasconcelos' project of having murals painted at the 'Escuela Nacional Preparatoria' by well-known artists marked the beginning of the popular Muralist movement.[11] Rivera's first mural, *Creation* (1925) (see p. 25), in the Bolivar Amphitheatre

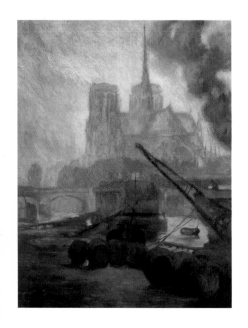

Diego Rivera
Nôtre Dame Paris 1909
Oil on canvas
144 x 133 cm
Museo Nacional de Arte (INBA),
Mexico City

opposite page:
Diego Rivera
*Motherhood — Angelina and
our Child Diego* 1916
Oil on canvas
132 x 86 cm
Museo de Arte Alvar y Carmen T. de
Carrillo Gil, MCG-INBA, Mexico City

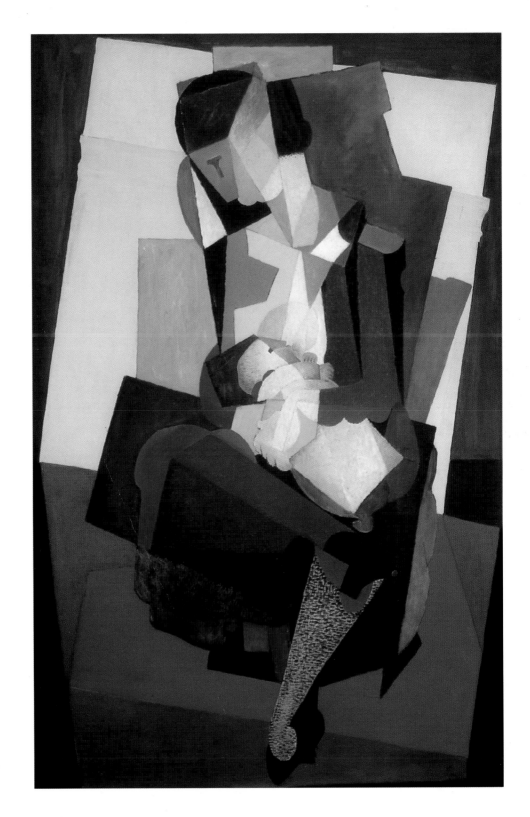

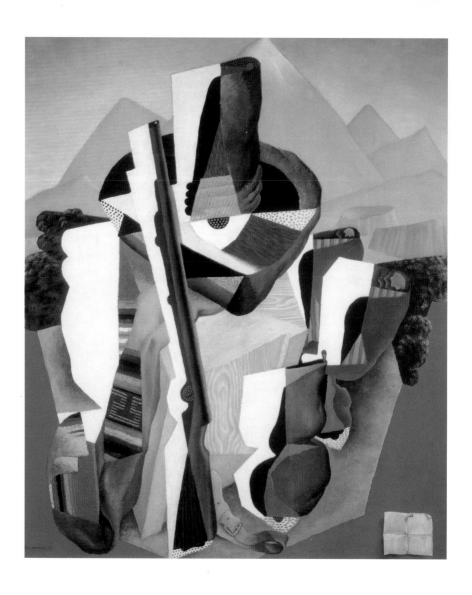

Diego Rivera
Zapatista Landscape—
The Guerrillero 1915
Oil on canvas
144 x 123 cm
Museo Nacional de Arte,
MUNAL-INBA, Mexico City

at the 'prepa', is a convincing blend of European, more particularly Italian, stylistic elements with traditional features of indigenous Mexican art such as expressive, brilliant colour. Going beyond the European pictorial conception of the Christian theme of Creation, the mural depicts the protagonists as people of all skin colours. Guadalupe Marín was Rivera's model for Eve, depicted, as one might expect, as a nude. Rivera had married her in a church wedding in 1922 and she bore him two daughters, Guadalupe and Ruth.

The year 1922 was significant in two respects for Rivera. First, it was the year he joined the Mexican Communist Party, the PCM. From then on he cemented his passionate commitment to the PCM with numerous contributions to the official Party organ, 'El Machete'. That year, Rivera also began to paint murals covering 1,600 square metres of wall space in the arcades surrounding the two inner courts of the three-storey building housing the Ministry of Education, the SEP (Secretaría de Educación Pública). It took him until 1928 to complete this vast mural. The murals in the smaller courtyard, the 'Fiesta Court', depict scenes of traditional Mexican folk festivals. Some details of these monumental pictures were later taken up again in Rivera's panel paintings, for instance in the *Bathers of Tehuantepec* (1923), quite similar to the mural in the Ministry of Education lobby. The coats of arms of the Mexican states as well as representations based on the theme of 'intellectual and scholarly work' adorn the walls of the first floor of the SEP and the second boasts the Corrido de Revolution, a cycle of murals narrating events in the Mexican Agrarian and Proletarian Revolutions. One picture in the Proletarian Revolution is *Arsenal* (1928) (see p. 26), in which Rivera portrayed several of his friends: the artist David Alfara

Diego Rivera
Creation 1922–23
Fresco with enkaustic and gold leaf
Surface area: 109.64 sq. m
Museo de San Ildefonso, Mexico City

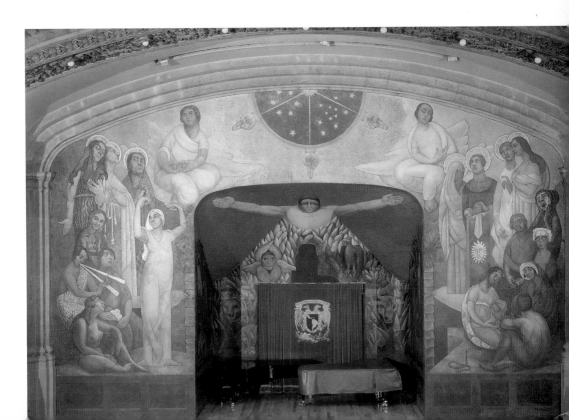

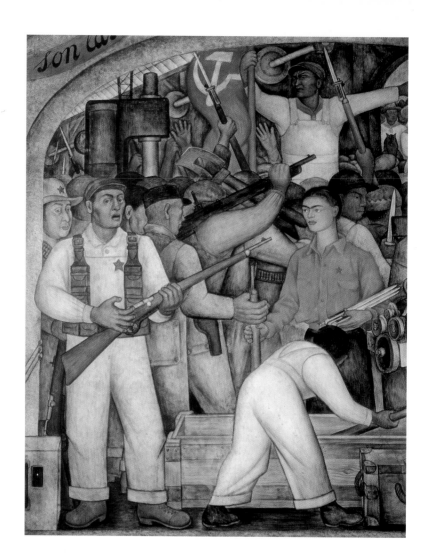

Arsenal—Frida Kahlo
distributing weapons
Detail from the cycle:
'Political Ideal of the
Mexican People'
(in the 'Fiesta Court')
1928
Surface area: 2.03 x 3.98 m
Secretaría de Educación
Pública-SEP, Mexico City

opposite page:
Diego Rivera
Liberated Earth with Natural Forces under
Man's Control. Mural from the fresco:
'Ode to the Earth and those who work upon
her for liberation' 1926–27
Nave. Surface area: 6.92 x 5.98 m
University chapel at the Autónoma de Chapingo,
Escuela Nacional de Agricultura, Chapingo

Siqueiros, the Cuban communist Julio Antonio Mella and
the woman he lived with, the photographer Tina Modotti,
and Frida Kahlo. This is the first portrait Rivera painted of
his future wife. Tomboyish and confident, Frida Kahlo and
her friends are depicted distributing weapons to the people.

While Rivera was still working at the SEP, he was commis-
sioned to decorate the agricultural school and the chapel
at Chapingo. The fresco cycles on the church walls are
The Social Revolution (on the left-hand side of the nave)
and Natural Evolution (on the right). The end wall of

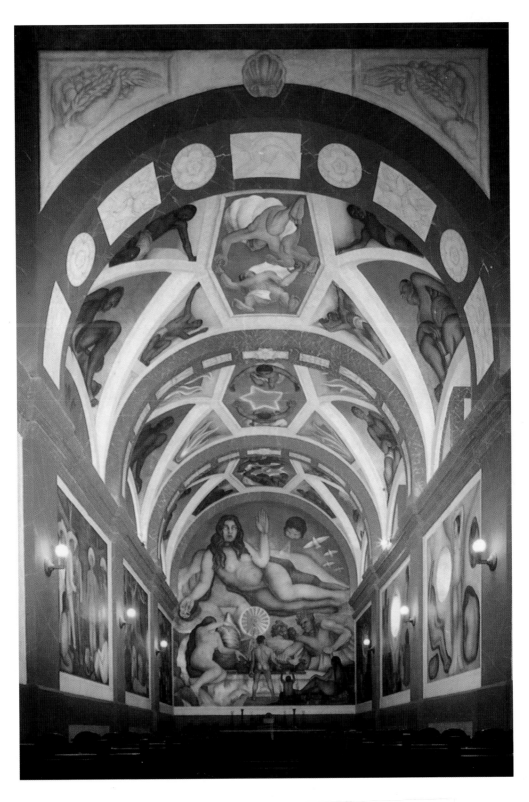

27

the building is dominated by a nude of his pregnant wife Guadalupe as a symbol of the earth's fertility. Tina Modotti also posed for the painter and they had an affair which led to a temporary separation from Guadalupe.

In 1927 Rivera finally left his second wife of many years. He decided to go to Berlin, where he attended a public rally of Hitler's and thus had quite a good idea of how things were going in Germany before the war. He also went to Moscow, where he spent ten months. There he took part in the tenth anniversary celebration of the October Revolution and heard Stalin speak. Rivera was to describe his arrival in Moscow as the most joyous occasion of his life because there he encountered a reality which corresponded exactly with his convictions and satisfied his most deeply-felt yearnings.[12] Political differences of opinion with his hosts thwarted Rivera's hopes of carrying out a mural project in the Red Army Club. Indeed, the Stalin government quite soon made it clear to him that his presence in the country was no longer desired. Rivera returned to Mexico in August 1928.

The dove and the elephant

There are many versions of the story of how Kahlo and Rivera first met, not least because the accounts given by both differed with each telling.

It is most likely that they were introduced to each other by Tina Modotti, who presided at salons for intellectuals in her house. Kahlo recalled:

'We got to know each other at a time when everybody was packing pistols; when they felt like it, they simply shot up the street lamps in Avenida Madero and they naturally got into a lot of trouble for that. At night they would take turns shooting or they just shot up the place for fun. Diego once shot the gramophone at one of Tina's parties. That was when I began to be interested in him although I was also afraid of him.'[13]

The better-known version of their first encounter is, however, the one in which Kahlo asked the master for advice about her painting:

'As soon as they let me go out into the street again,
I grabbed my pictures and set out to see Diego Rivera,
who was working on murals at the ministry of education
at the time. I didn't know him personally but I admired
him immensely. I even had the nerve to tell him to come
down from his scaffold and to ask him his opinion of my
pictures. Without beating about the bush, I called out:
"Diego, come down!" and, modest and obliging as he is,
he did come down. "But I haven't come here to flirt,"
I said, "even though you're a notorious ladies' man. I just
want to show you my pictures. If you find them interest-
ing, tell me; if not, tell me anyway because then I'll find
something else to do to support my family." He looked at
my stuff for a while and then he said: "First of all, I like
the self-portrait, that's original. The other three pictures
seem to have been influenced by things you must have
seen somewhere. Now go home and paint another picture.
Next Sunday I'll come and tell you what I think of it." He
did just that and his verdict was that I was talented.'[14]

Rivera was enchanted by Kahlo's youthful grace, her natural-
ness, the cheeky way she had about her, her flamboyance
and fiery impetuosity and, of course, by her innate talent
for painting. It wasn't long before Rivera was visiting Kahlo
at the Blue House every Sunday and was seriously courting
her. One day Frida Kahlo's father took Rivera aside and
asked him: 'I've got the feeling you're interested in my
daughter, isn't that so?' 'I certainly am,' replied Rivera,
'otherwise I wouldn't come all the way to Coyoacán so
often.' 'Do you realize she's a little devil?' Guillermo Kahlo
said. 'I know,' replied Rivera. 'All right, you've been warned,'
was Guillermo Kahlo's final word on the subject.[15]

Kahlo and Rivera were married on 21 August 1929. Only a
few close friends were present at the ceremony. This was
Rivera's first civil marriage. Kahlo borrowed a skirt, blouse
and rebozo, a Mexican stole, from her maid. Rivera wore a

nondescript grey suit. Kahlo's parents were not at all pleased about their daughter's marriage since they felt that Rivera looked like an overfed rustic from a Brueghel painting, indeed that the wedding ceremony was like the marriage of an elephant and a dove. In the midst of these modest nuptials, Guillermo Kahlo exclaimed: 'Gentlemen, don't you feel that we're making rather too much of a fuss about nothing here?'[16]

There were several rather disturbingly inauspicious, even nasty, incidents at the wedding. Lupe Marín, who was there, lifted up her rival's skirt and shouted: 'Do you see those two canes. That's what Diego's going to have to put up with now and he used to have my legs!'.[17] With that she swept out of the room. By the early hours of the morning, Rivera was so drunk that he started firing off his pistol at random and even broke a guest's finger. The newlyweds had a fight, Frida Kahlo left the party in tears and they spent their wedding night apart. Kahlo didn't move in with Rivera until several days later.

When they did decide to live together, their first home was Rivera's house at 104 Paseo de la Reforma. In the month they were married Rivera was appointed director of the San Carlos Academy, where he had studied art in his early youth. He proceeded to inaugurate reforms and the upshot was that he was sacked in the middle of 1930. More important-ly, Rivera was commissioned to decorate the stairwell in the National Palace in Mexico City with murals. The mural cycle in the National Palace represents an ambitious nar-rative of Mexican history, beginning with the era before the Spanish Conquistadors and continuing on up to the events of the 1920s and '30s, a time of conflict between Mexico and its powerful and menacing northern neighbour. Between 1929 and 1935 Rivera worked in the stairwell, executing three thematically-linked frescoes, which to-gether make up the Epic of the Mexican People. By 1942 he was working on the first storey of the courtyard. The way Rivera depicted the struggle of the Mexican people against oppression mirrors his communist convictions. Very explicit and extraordinarily dense in composition,

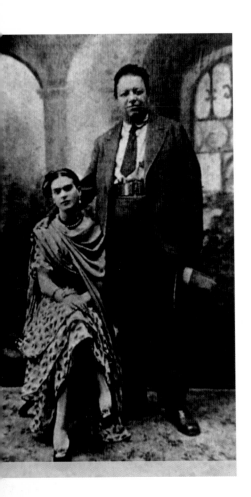

Frida Kahlo and Diego Rivera in Coyoacán
on their wedding day in August 1929
Photo: Archivo CENEDIAP-INBA, Mexico City

the mural cycle narrates historic events in scenes crowded with figures and reveals the artist's thorough grounding in history as well as his profound knowledge of art history.

In December of that year, the muralist accepted a commission from the United States Ambassador, Dwight W. Morrow, to decorate the Cortés Palace in the nearby city of Cuernavaca. Until autumn 1930, Rivera worked there on *The History of Cuernavaca and Morelos, Conquest and Revolution.* Kahlo often looked over the master's shoulder, was ready with helpful critique and even managed to exert an influence on his work. In later years her advice became increasingly important to him. By now they were living in Cuernavaca in Morrow's weekend house. It seems ironic that Rivera, a committed communist, should have been working for an American capitalist. His indiscriminate approach to accepting commissions in fact led to Rivera's expulsion from the Communist Party in 1929. When he first heard of it, Rivera sat down at his usual place at a Party convention, with a pistol covered by a handkerchief

Diego Rivera
The Conquest or Arrival of Hernàn Cortés in Veracruz, from the fresco cycle *'Precolonial and colonial Mexico'* 1942–51
Fresco cycle on movable metal frames
Section 11 on the east wall. 4.92 x 5.27 m
National Palace, Mexico City

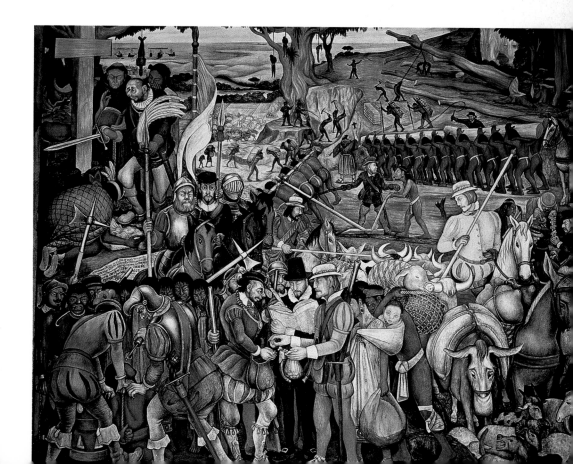

before him on the table and announced: 'I, Diego Rivera, General Secretary of the Communist Party of Mexico, accuse the painter Diego Rivera of collaboration with the petty bourgeois Mexican government. He accepted a commission to decorate the stairwell of the National Palace. This contravenes the interests of the Comintern. Therefore the painter Diego Rivera must be expelled from the Communist Party by the General Secretary Diego Rivera.'[18] With that he stood up, picked up the handkerchief and broke the pistol into pieces. It was made of clay.

Diego Rivera
The History of Cuernavaca and Morelos,
Conquest and Revolution 1930–31
Fresco comprising 8 murals and 11 grisaille
paintings, 149 sq. m
Overall view of the loggia
Museo Quaunahuac, Instituto Nacional de
Antropologiá e Historia / INAH, Cuernavaca,
Morelos
Photo: Rafael Doniz

Kahlo, who had joined the Communist Party in 1928, immediately left it in solidarity with her husband. Rivera, who was deeply hurt by his expulsion from the Party, especially since he remained steadfast in his communist convictions, now threw himself into his work with a vengeance.

Kahlo didn't paint at all the first few months after they married. When she did begin again, it was with reluctance and even aversion. Rivera spent days and nights at a time on his scaffold and had little time for her, and she needed something to do. Her life at this time revolved around her husband and making him happy. She loved to make lunch baskets for him, decorated with flowers the way he liked

Frida Kahlo
Self-Portrait 1930
Oil on canvas
65 x 55 cm
Museum of Fine Arts, Boston

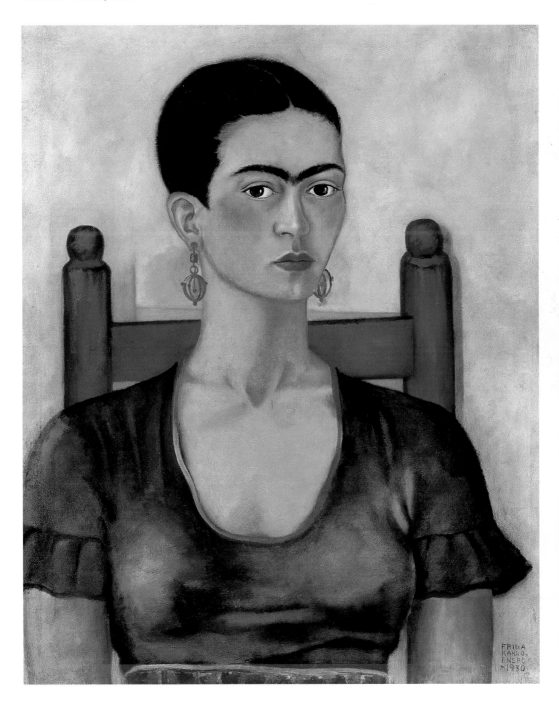

them, and used to climb up his scaffold to join him. Lupe, her erstwhile rival, gave her a few hints and tips 'from woman to woman' and the two became reconciled to each other and even friends. In appreciation of all Lupe's good advice, Kahlo painted a portrait of her.

In 1929 Kahlo painted a second self-portrait and *The Bus*, in a small format. Knowledge of Kahlo's life history would lead one to conclude that this painting had something to do with the bus accident which had caused her so much suffering, and might even dispose one to imagine that one of the people portrayed had witnessed the accident. However, the painting does not contain any explicit references to support this conjecture. All one can safely assume is that Kahlo surely would not have been able to paint a bus scene without being reminded of the tragedy that changed her life. People from various walks of life are depicted in the painting: a worker and a working-class woman, a barefoot Indio woman and a stylish-looking, light-skinned couple, obviously upper class. When one compares Kahlo's self-portraits of 1929 and 1930 with the self-portrait she painted in 1926, one is immediately made aware of how she has become imbued with Mexicanismo, pride in Mexican national identity as distinct from North American and European influence. Kahlo had found herself and showed that she had with great dignity. From now on she chose to wear the national costume of the Tehuantepec Isthmus. She decked herself out in striking jade and silver Mexican jewellery, wove bright ribbons into her plaits, which she wore up, decorated with flowers and combs. Kahlo turned herself into a work of art and, in so doing, expressed earthy feelings for the soil of her homeland.

In Cuernavaca Kahlo had a miscarriage at three months, her first of many, and this sparked off a crisis in her marriage which was exacerbated by her discovery that her husband was having an affair with one of his assistants. Kahlo once said that she was visited by two catastrophes in her life, the first being when she was hit by a tram, the second catastrophe being Rivera.[19]

Gringolandia—the years in America

As the 1920s were drawing to a close, the Mexican
Muralist movement ran out of steam. Concomitantly,
the political situation became so dangerous that it was
more than one's life was worth to express communist
sympathies in public. Rivera was eager to try something
new. Consequently he and Kahlo set off in November 1930
for San Francisco, where he had been commissioned to do
some work. There they were most hospitably received by
Albert Bender, an art collector of international repute. The
communist couple owed their right of entry into the United
States solely to Bender's untiring exertions on their behalf.
Kahlo expressed her appreciation by dedicating the wedding
double portrait, *Frida and Diego*, to him (see p. 37). Here
Kahlo has portrayed herself as a devoted wife at her forceful
and famous husband's side. He, the celebrated artist, is
represented with brushes and palette in his hand. Kahlo
still enjoyed portraying herself in the role of submissive
Mexican wife. A dove bears in its bill the banderole with
the dedication to her friend Albert Bender.

For Rivera the eight months in San Francisco were a
successful and lucrative interlude. There was a compre-
hensive retrospective of his work in the California Palace
of the Legion of Honor in December 1930. After that he
began on a fresco depicting the California Allegory in the
Luncheon Club of the Pacific Stock Exchange. From April
1931 he devoted himself to a fresco in the California School
of Fine Arts, *The Realization of a Fresco* (see p. 39). Here the
artist has depicted a mural painter sitting on a scaffold with
his back to the spectator. Kahlo, too, who hardly saw her
husband, so busy was he with commissions, also painted
important pictures in California and this development
heralded a change in her personality. In San Francisco she
was often alone or spent time with a friend, the painter
Lucile Blanch. The way Kahlo saw things was greatly en-
riched by the host of new impressions crowding in on her
and she turned towards Fantastic Realism. This is particular-
ly evident in *Luther Burbank* (1931) (see p. 38). The botanist
and pioneering cross-breeder of plants, famous for creating

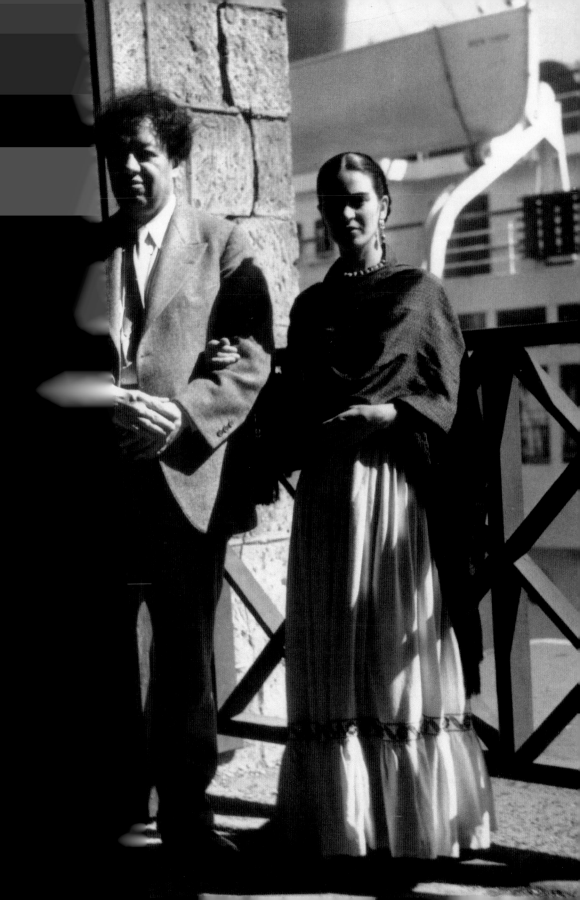

new species, is represented as a cross between a man and a tree. Kahlo may have been inspired to try out this new form of expression by drawings of her husband's, whose influence is apparent in some of her work. This is certainly the case with her late work, when she was striving to give her art a political foundation at the end of her life.

In San Francisco Kahlo met Dr Leo Eloesser, who was to remain her personal physican and a lifelong friend. His advice was invaluable to her in many of her life's worst crises. He gave her a thorough physical examination for the first time in 1930 and discovered that her spine was congenitally crooked and lacked one vertebra. In addition, Kahlo's right foot hurt so much that she found it increasingly difficult to walk. In 1931 she dedicated her *Portrait of Dr. Leo Eloesser* to her friend and physician (see p. 40). In it he poses next to a model sailing vessel.

Kahlo didn't care much for American women. 'I can't stand Gringos, they're boring and have doughy faces like

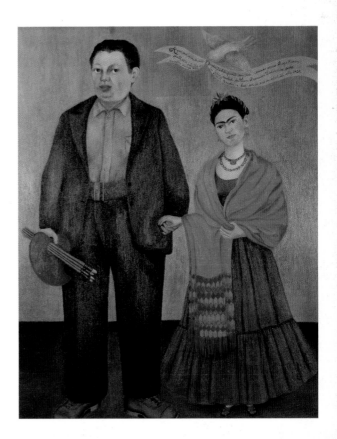

opposite page:
Frida Kahlo and Diego Rivera. c. 1930
Photo: Manuel Alvarez Bravo, 1930

right:
Frida Kahlo
Frida and Diego Rivera or
Frida Kahlo and Diego Rivera 1931
Oil on canvas
100 x 79 cm
San Francisco Museum of Modern Art,
San Francisco

Frida Kahlo
Luther Burbank 1931
Oil on board
86.5 x 61.7 cm
Dolores Olmedo Patiño Museum,
Mexico City

opposite page:
Diego Rivera
The Realization of a Fresco 1931
Fresco, 5.68 x 9.91 m
San Francisco Art Institute,
San Francisco

unbaked rolls, especially the old women,'[20] was her plaint. Kahlo and Rivera returned for a short while to Mexico in July since Rivera was supposed to continue work on his fresco in the National Palace. Kahlo was once again breathing the Mexican air she had been so homesick for. She could walk in the gardens of the Blue House and enjoy the companionship of old friends. At that time Rivera commissioned a friend, the architect and painter Juan O'Gorman, to build a house in the San Angel quarter of Mexico City as a home for himself and his wife. However, two houses were built—a big one for him and a smaller one for Kahlo. Only a bridge joins the two houses. Rivera thus expressed in architecture his understanding of, and sympathy with, the idea of independence in a relationship between a man and a woman.

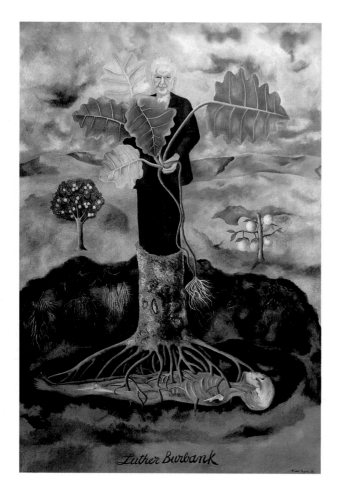

Luther Burbank

Kahlo did not have much time to enjoy her own dear country. Rivera was invited to stage a large retrospective of his work in the New York Museum of Modern Art. It was the second one-man show mounted in the museum, which had opened with a Matisse exhibition. Rivera again stopped work on the National Palace murals. He was not to finish the stairwell murals until 1935, and even then, the overall work remained unfinished. Rivera and Kahlo went straight to Manhattan. The exhibition comprised 150 paintings, including work from Rivera's Cubist phase. Watercolours and drawings were shown as well, and—the star attraction—seven portable fresco panels which Rivera painted for the exhibition. Nearly 60,000 people visited the exhibition and among their number were important artists, art critics and patrons of the arts.

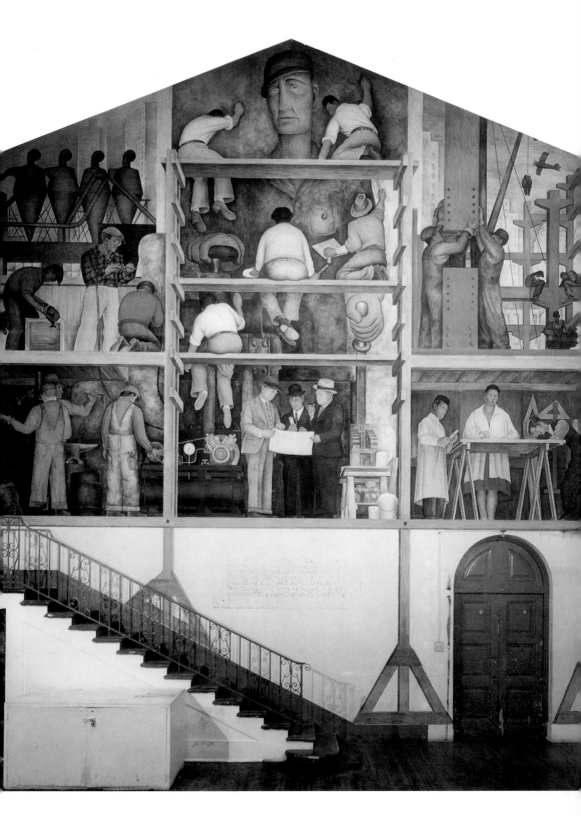

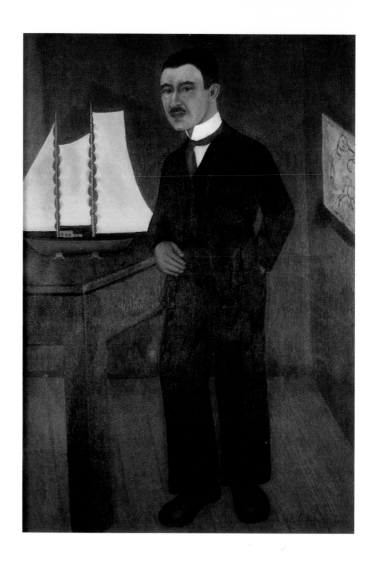

Frida Kahlo
Portrait of Dr. Leo Eloesser
1931
Oil on board
85.1 x 59.7 cm
University of California, School
of Medicine, San Francisco

Kahlo, just 24 at the time, was viewed as shy and retiring, overshadowed by her famous husband. She had a new friend, to spend her time with, Lucienne Bloch, daughter of the Swiss composer Ernest Bloch. Rivera's popularity forced Kahlo to appear at innumerable gala dinners and move in arty circles, which she hated doing. She wrote to Dr Eloesser: 'This upper class is disgusting and I'm furious at all these rich people here, having seen thousands of people in abject squalor.'[21]

In 1932 Kahlo and Rivera moved to Detroit because Rivera had been commissioned by William Valentiner to paint

frescoes in the inner courtyard of the Detroit Institute of Arts. The theme was supposed to be Detroit Industry and, in his fresco cycle, Rivera succeeded in portraying Henry Ford's empire as a Marxist saw it. Rivera's slant on industrialism was tolerated because, at that time, the chattering classes thought it was chic to be open-minded about communism, albeit without attaching much importance to it. Another reason for the *laissez-faire* attitude of American art lovers to the mural was the worldwide recession. The state of the global economy inspired Ford to demonstrative gestures of sympathy with America's poor neighbour to the south, perhaps in the hope of opening up new markets there.

Kahlo used her second Christian name, Carmen, when introducing herself to people in Detroit since her German-sounding first name would not have met with a warm response in those pre-war days. She went everywhere dressed so extravagantly that people in the street turned to look at her. Finding the Americans tedious, the more so the longer she stayed in Detroit, Kahlo increasingly resorted to sarcasm as a way of relieving her boredom in public. Characteristically, she approached Henry Ford, a notorious anti-Semite, and, assuming a naive manner, asked him whether he was Jewish. One imagines Rivera finding this hilarious. As distinguished visiting artists, Kahlo and Rivera were staying at the Wardell Hotel, to which Jews were not admitted. The Riveras proclaimed that they were Jewish and would have to move out immediately. The hotel management instantly revoked the prohibition on Jews.

A tropical lesion had developed on Kahlo's toe and she was generally in poor health. In Detroit she became pregnant for the second time. Although she longed for Rivera's child, she was so afraid of pregnancy in her condition that she was torn between her desire to keep the baby and, as she saw it, the practical necessity of an abortion. The decision was not to be hers. In the fourth month of pregnancy, she had a miscarriage on 4 July 1932. Lucienne Bloch writes: 'There was a huge pool of blood by her bed and she kept on losing blood on the way to hospital. She looked so tiny,

like a twelve-year-old, and her plaits were wet with her tears.'[22] She was taken to Henry Ford Hospital, where she became alarmingly depressed. Once again it was art that helped Kahlo out of a life-threatening depression and kept her alive. She asked a doctor to bring her medical books with clinical illustrations of embryos. Since this seemingly perverse wish was not granted, Rivera had to come to her rescue and provide her with the books she wanted. Kahlo began at once to produce drawings of male embryos. The two pictures *Henry Ford Hospital* and *My Birth* (1932) (see p. 34) bear haunting witness to the sorrow she felt at this devastating loss. In *Henry Ford Hospital* a naked, vulnerable Frida is exposed to the spectator, lying with the belly of a pregnant woman but with a grey, tear-streaked face in her own blood in a hospital bed. Her surroundings are depicted as cold and oppressive. The figure of Frida is bound by strings, recalling umbilical cords, to overtly sexual symbols like a snail and flowers and others signalizing her miscarriage, her foetal child and her deformed pelvis. This is the first painting executed by Kahlo in the 'retablos' mode, inspired by the traditional Mexican vernacular votive image, on metal, a technique the artist was often to use from then on. She later appropriated entirely the vigorously primitive vernacular idiom of Mexican folk art.

Rivera set up a lithography workshop for their use and Kahlo embarked eagerly on exploring this, to her, new technique by drawing *Frida and the Miscarriage* on lithography stones and printing them. However, the results disappointed her and this was to be her only attempt at working in the medium of lithography.

On learning in September that her mother was dying, Kahlo insisted on setting out for home at once. Rivera, still worried about Kahlo's health, asked Lucienne Bloch to accompany his wife on the trip. In this case modern technology proved woefully inadequate when it was really needed. It was not possible for Kahlo to telephone her family in Mexico, nor was a flight available. Weak and depressed as she was, Kahlo was forced to travel the entire distance by train and bus. Once again Kahalo was in for a hard time.

Frida Kahlo posing in front of an incompleted mural by Diego Rivera. Photograph taken in 1933 in the New Workers' School, New York
Photo: Lucienne Bloch

On 15 September her mother died of cancer. Kahlo spent a lot of time with her family and kept her father's spirits up. Yet soon she was missing her 'beloved Diego' so much that she could no longer stand to be apart from him. She went back. The 'retablo' *My Birth*, which she had begun before leaving for Mexico, was completed after her return to Detroit. Her own mother is depicted wrapped in a shroud at Kahlo's birth. Both mother and child look lifeless. Was Kahlo conjuring up the death of her mother? Or does this mean that she could not be born until her mother was dead? Nothing seems to connect mother and child here. Cold and isolation dominate the picture space. A picture of the Mater dolorosa, a bleeding and weeping Virgin, hangs over the bed in the centre. The banderole in the lower part of the picture, which, in a real votive image of the sort consecrated to saints in gratitude for miraculous cures would contain words of thanksgiving, is here empty. Kahlo saw no reason to express gratitude. At first glance,

Diego Rivera
The Industry of Detroit or
Man and Machine 1932–33
Fresco
South wall
The Detroit Institute of Arts, Detroit,
Michigan (Gift of Edsel B. Ford)

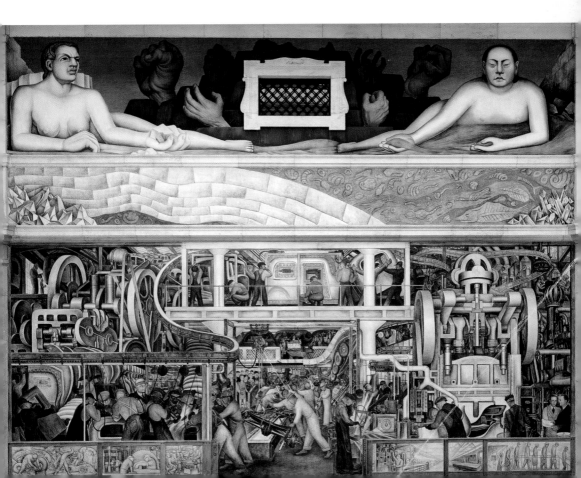

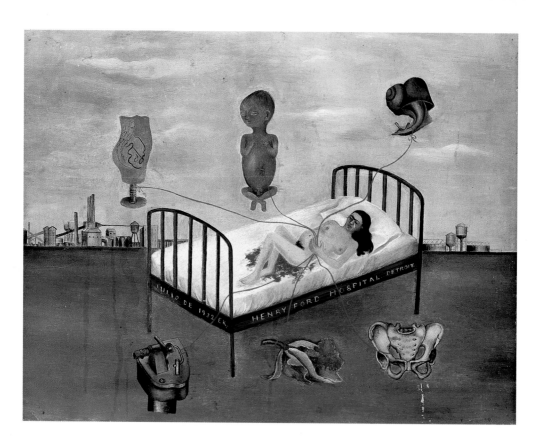

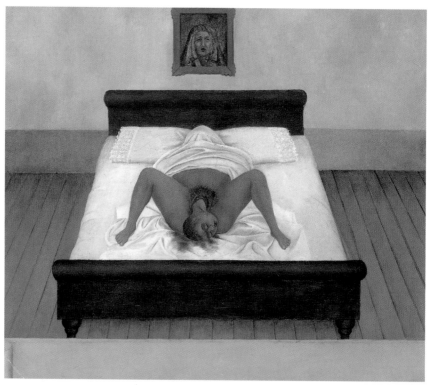

her 'retablos' do indeed resemble the ones hanging in every Mexican church. Kahlo's representations are always of dramatic autobiographical events, painted in small formats on metal in the brilliant colours of Mexican vernacular art and provided, like Mexican vernacular 'retablos', with banderoles. However, Kahlo's 'retablos' are not expressions of thanksgiving; on the contrary, they represent laments, cries of despair at the pain she suffered. *My Birth* is brutally unillumined by divine grace since Kahlo felt herself to have been treated cruelly, or rather abused, by fate.

In October 1932 Rivera was commissioned to paint a mural in the Rockefeller Center, New York, and in January 1933 he was supposed to contribute a fresco on the theme of 'Industry and Machinery' to the Chicago World Fair. The mural he painted for the Rockefeller Center placed him squarely in the crossfire of sniping critics. The explicit communist message of the work, with Lenin and the working class on one side and the ruling classes who could afford art on the other, was too much for the giants of industry who had commissioned *Man at the Crossroads*. They had the mural covered over and it was to be left unfinished. Rivera was paid for what he had done and sacked, disgusted with the cowardly stance of his young patron, Nelson Rockefeller, who refused to prevent the muralist's humiliation by intervening on his behalf. In 1934 the mural was destroyed, yet that year Rivera was in some measure compensated for the Rockefeller débâcle by being commissioned to paint a replica of the fresco in the Palacio de Bellas Artes in Mexico City, entitled *Man Controls the Universe or Man in the Time Machine*.

All Kahlo wanted to do was to return to Mexico with her husband and stay there. Arguing heatedly with him about the necessity of taking this step, she was subjected to Rivera's outbursts of rage, which invariably ended with his walking out and slamming the door, not to return until daybreak. Rivera enjoyed being lionized and was in no hurry to return to Mexico. Still Kahlo carried the day. How homesick she was can be seen in the poignant *My Dress is Hanging There*, the only painting she managed to embark

opposite page, top:
Frida Kahlo
Henry Ford Hospital or The Flying Bed 1932
Oil on metal
30.5 x 38 cm
Dolores Olmedo Patiño Museum, Mexico City

opposite page, bottom:
Frida Kahlo
Birth or My Birth
1932
Oil on metal
30.5 x 35 cm
Private collection, USA

on during the nine months spent in New York. She did not finish it until she returned to Mexico. Her Tehuana dress is depicted as hanging, lonely and out of place, in the bustle and noise of a modern society without the presence of human beings. She herself is not there; she has long since withdrawn from the world which she found so inhuman and lacking in culture.

Kahlo ultimately won the battle which had been raging between the Riveras for months. On 20 December 1933 they sailed for Mexico on the *Oriente*, which called at Cuba on the way. Kahlo was at home at last.

The dark side of the relationship

Back in Mexico, Kahlo and Rivera moved into their new house in San Angel. Although she had had her own way about returning to Mexico, Kahlo had to pay too high a price for her victory. Rivera never tired of letting her know how he resented having to give up his triumphs in the United States. He would lapse into apathy, refuse to work, found everything he had done no good at all and finally even fell ill, blaming Kahlo for all the evils he claimed had befallen him. Not until November 1934 did he pull himself together and resume work on his murals for the main stairwell of the National Palace. By the following year it was more or less finished. His marriage seemed to be, too, as the relationship had grown increasingly stormy.

Kahlo suspected that Rivera was having another affair. She began to spy on him and, what she found out was a blow to her and mortifying in the extreme. Rivera was carrying on a liaison with her sister Cristina. Outraged and deeply hurt, Frida Kahlo found herself betrayed by the two beings she loved most in the world. The situation was made worse by her precarious state of health. She had a third miscarriage, this time in the third month, had to have an appendicectomy and her right foot hurt her so that she finally agreed to have all five toes amputated. Rivera showed himself capable of behaving like a brute, a character trait

Frida Kahlo
*My Dress is Hanging There
or New York* 1933
Oil and collage on board
46 x 50 cm
Hoover Gallery San Francisco,
Heirs of Dr. Leo Eloesser

he was the first to admit he had, by refusing to end the affair with his sister-in-law even after Kahlo had found out. For months on end Kahlo had to endure the greatest humiliation of her life. Rivera added insult to injury publicly by painting his wife with her sister in *Mexico Today and Tomorrow*, part of the fresco trilogy *Epic of the Mexican People* in the National Palace. Cristina is portrayed elegantly dressed, in a self-assured, very feminine pose, proudly ob-

scuring Frida with her two children. Frida Kahlo is portrayed as unattractive and insignificant. Cristina, by contrast, is strikingly beautiful and elegant. Her eyes are shown wide in orgastic ecstasy, Rivera's convention for portraying woman he was sleeping with, which denotes their degradation to

47

mere objects of his lust. Only Frida Kahlo, of all his women, was notably spared such cavalier treatment. She wrote to Dr Eloesser at the time:

'The situation with Diego is getting worse every day. I know I'm to blame for much that has happened because at the outset I didn't understand what he really wanted and because I fought against something that can no longer be made up for. Now, after so many months of terrible distress, I've forgiven my sister and I had thought everything would get better now but just the opposite has happened. Of course, the situation may be more tolerable for Diego now but it has remained horrible for me. I'm so down and discouraged now, so unhappy that I don't know how I'm to go on. I realize that Diego is now more interested in her than me and I keep saying to myself that I have to be ready to accept compromises if I want him to be happy. But it's costing me so much to put up with all this and you can't imagine how I'm suffering. (...)'[23]

Rivera had this to say about himself in his autobiography: 'When I loved a woman, I wanted to hurt her the more I loved her; Frida was the most evident victim of this despicable character trait of mine.' That year Kahlo was unable to paint at all.

The following year she painted a frightening murder scene, based on a real occurrence that had filled the newspapers. A man had stabbed his wife to death but had told the police that he had only slashed at her without intent to kill. Kahlo took advantage of this tabloid horror story to portray her own suffering. She may indeed have forgiven Rivera and her sister but she was unable to come to terms with her own sorrow and anger. In *A Few Little Slashes with a Dagger* (see p. 50) we see the murderer standing next to a bed on which a naked woman with a wounded and battered body is lying dead. The sheet, the murderer's clothes, the floor, even the picture frame, are smeared with blood. Rivera had ostensibly just 'slightly hurt Kahlo with a dagger' without being aware of how deeply he had wounded her.

A picture frame spattered with blood recurs in the retablo-like painting *Dorothy Hale's Suicide* (1939). Dorothy Hale was a beautiful but wretchedly unhappy woman who had jumped to her death from Hampshire House. Kahlo wanted to paint a memento for a patroness who had really known Dorothy Hale and had commissioned a portrait of her. However, when the poor woman saw a brutal representation of her friend's death instead of a portrait which preserved her dignity, she was appalled.

In later years Kahlo continued to make the suffering she had endured from Rivera's affair with her sister the theme of paintings, for instance in *Memory or The Heart* (1937) and *Memory of an Open Wound* (1938).

In *Memory or The Heart* (see p. 51), Kahlo portrayed herself with heart wrenched out to throb bleeding on the ground. This simple representation of the pangs of love is easier to understand when one considers that the artist's Aztec ancestors sacrificed hearts torn out of living people to their gods. Moreover, the heart torn out of the body crops up continually as a symbolic representation in Mexican art.

Diego Rivera
Mexico before the Spanish—The Ancient Indian World, from the fresco cycle *'Epic of the Mexican People'* 1929–35
Fresco
North wall. 7.49 x 8.85 m
National Palace, Mexico City

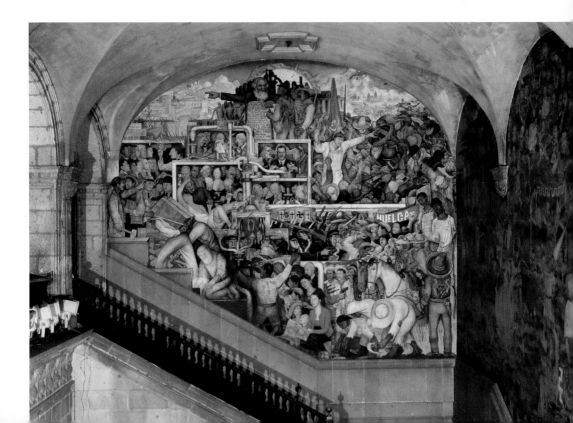

Kahlo, with her bent for Mexicanismo, was employing a common vernacular metaphor. In this picture Kahlo's hair has been shorn off. Her reaction to her husband's affair with Cristina had in fact been to cut off her beautiful long hair so that she may in this case be said to have thus chastized him by castigating herself in the medium of oils. She was

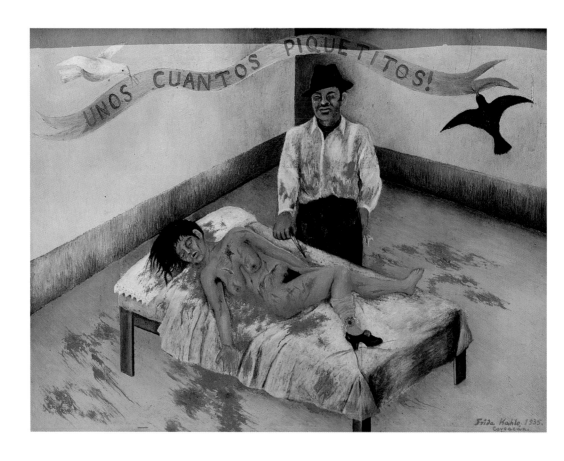

Frida Kahlo
A Few Little Slashes with a Dagger
1935
Oil on metal
29.5 x 39.5 cm (with frame: 38 x 48.5 cm)
Dolores Olmedo Patiño Museum, Mexico City

so sad that she even stopped wearing her beloved Tehuana dresses. In the oil painting on metal, her Tehuana dress is shown hanging on her left and her old, self-imposed school uniform on her right. She herself is here dressed in the white skirt and blouse and jacket which can be seen in a photo taken in 1935 by Lucienne Bloch. This is one of the few photos in which Kahlo has short hair. In one hand she is holding a Cinzano bottle, attesting to the fact that she was drinking quite heavily by this time.

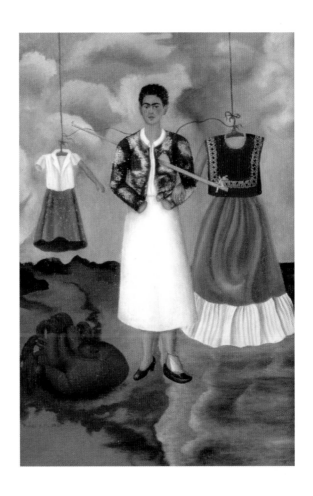

Frida Kahlo
Memory or The Heart
1937
Oil on metal
40 x 28 cm
Private collection

The relationship between Kahlo and Rivera was becoming intolerable for both. In 1935 Kahlo moved out of their house in San Angel and into a flat she rented in the capital. Not long afterwards she went to New York with two women friends and without her husband. From that time on she had promiscuous affairs with both men and women and seemed to have lost all her inhibitions. Her husband's jealousy still prevented her flaunting her affairs in public. Although Rivera never bothered to hide his love affairs, Kahlo felt justified in satisfying her sexual drive in secret because one can vividly imagine what her husband, driven as he was by jealousy and wounded masculine vanity, might have been capable of. Surprisingly, Rivera found nothing wrong in Kahlo's having lesbian affairs: 'The male sexual organ is confined to one place whereas female

genitals are distributed all over the female body,' he once remarked. 'For this reason two women can have entirely different and incredibly satisfying sex with each other.'[24] When she had heterosexual affairs, on the other hand, he was furious. This was the case in 1935 when Kahlo had an affair lasting eight months with the handsome sculptor Isamu Noguchi, who was passionately in love with her. One account has it that the affair ended when furniture which had been ordered for a trysting place the couple were decorating was sent by mistake to Rivera's house in San Angel and the bill for it was sent to Kahlo's husband. According to another version, the two men met when both were visiting Kahlo in hospital. Rivera is said to have menaced Noguchi with a pistol, threatening to shoot him dead next time. Kahlo really did care for Noguchi. He had comforted her at a difficut time in her life and restored her self-esteem. However, nothing could conquer her love for Rivera and she eventually returned to her husband.

The affair with Leo Trotsky

As early as 1933, Diego Rivera had come out publicly for the Trotskyists. When the Norwegian government refused to grant asylum to the Russian revolutionary Leo Trotsky, who had been expelled from the USSR in 1929, Rivera personally interceded for him with the Mexican President, Lázaro Cardenas. Rivera's petition was granted and Trotsky was permitted to settle in Mexico. In January 1937 Frida Kahlo and two members of the American Trotskyist faction met Leo Trotsky and his wife, Natalya Sedova, on their arrival at the port of Tampico. Ill-health at the time made Rivera, to his great regret, unable to accompany his wife to Tampico. Still when the party arrived in Mexico City by special train, he was there too, after being discharged temporarily from hospital. Kahlo and Rivera took the Trotskys to the Blue House and allowed them to stay there without paying rent until 1939. Kahlo's father was living alone at the time and Rivera and Kahlo lived in San Angel. When Trotsky arrived in Mexico, he was 57 years old and Kahlo was 29. She knew how her husband admired Trotsky and

After discovering Diego Rivera's relationship with her own sister, Cristina, Frida Kahlo cut off her long hair—which her husband had liked so much. Diego's frequent infidelity resulted in Kahlo's fleeing to New York where she led her own promiscuous life.
Photo: Lucienne Bloch, 1935

opposite page:
Guillermo Davila photographed Frida Kahlo, while her hair was growing back, on the occasion of her visit to Xochimilco, Mexico. Date unknown
Photo: Archivo CENIDIAP-INBA, Mexico City

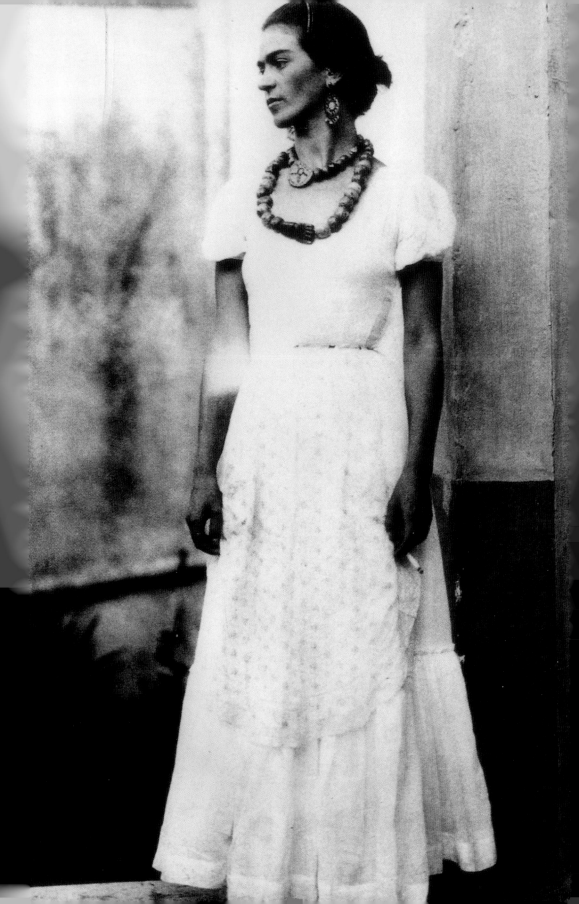

this may have made an affair with him particularly piquant, aside from the fact that Trotsky really was an attractive and charismatic man. Trotsky for his part saw in Kahlo a proud and self-assured young woman, whose feelings about herself had been given a boost by the affair with Noguchi. *Fulang Chang and I* (see p. 56), painted that year, is electric with eroticism. In it Kahlo has portrayed herself *en femme épanouie*, sensuality personified, accompanied by a monkey symbolizing lust and promiscuity. The background is remarkable for phallus-like cacti. This picture marks the first occasion of Kahlo's representing a lover, or the existence of one, as a monkey. A pink ribbon is coquettishly tied about her neck and that of the animal.

An affair soon developed between Trotsky and Kahlo. The Russian laid *billets doux* in books he lent to Kahlo and they met secretly in her sister Cristina's house. When Natalya found out, the situation became intolerable. According to Trotsky's secretary, van Heijenoort, the affair between the revolutionary and the painter soon proved too hot for both parties to handle. 'They both stepped back from it. Frida felt herself under an obligation to Diego and Trotsky felt the same about Natalya. On the other hand, a scandal might have been led too far.'[25] By late July the affair was over. Who ended it is unclear. Rivera himself had heard nothing at all about this extramarital liaison of his wife's. Kahlo may have viewed it as a fitting revenge for his affair with Cristina. After all, Rivera venerated Trotsky and had become a good friend of his. On 7 November 1937, Trotsky's birthday, Kahlo gave the revolutionary a rather unusual present: her *Self-Portrait Dedicated to Leo Trotsky* (see p. 57). Here she has portrayed herself as an elegant colonial aristocrat. 'On the wall of Trotsky's office,' remarked André Breton, 'I admired a self-portrait of Frida Kahlo Rivera. Clad in gilt butterfly wings, in just such a garment, she has opened the inner curtain a crack. We are, as in the heyday of German Romanticism, permitted to be present at the performance of a young woman who is endowed with all the gifts of seduction and whose being unfolds among men of genius.'[26]

Kahlo's first New York exhibition

Since the affair with Trotsky, Kahlo had been again devoting herself to her calling and the years 1937–38 saw one of her most productive phases. Painting now assumed much greater importance for her, becoming an inner necessity.

Frida Kahlo and Leo Trotsky. The older, politically experienced revolutionary and the young artist felt a mutual fascination for one another.
Photo: Archivo CENIDIAP-INBA, Mexico City

In spring 1937 she wrote to Ella Wolfe: '(...) as you notice, I've also been painting. That is saying a good deal since up to now I've been spending my time loving Diego and, as far as painting is concerned, have done nothing worth showing; nevertheless, now I'm seriously painting apes (...)'.[27]

Kahlo was again preoccupied with the theme of motherhood, which may point to a fourth miscarriage. In *My Doll*

55

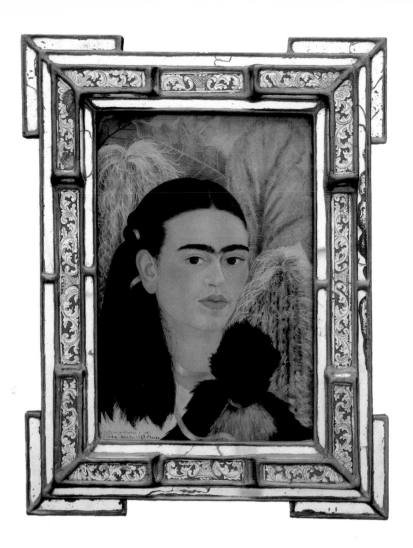

Frida Kahlo
Fulang Chang and I
1937
Oil on board
40 x 28 cm
The Museum of Modern Art,
New York

opposite page:
Frida Kahlo
*Self-Portrait dedicated to Leo Trotsky
or 'Between the Curtains'* 1937
Oil on canvas
87 x 70 cm
The National Museum of Women
in the Arts, Washington D.C.

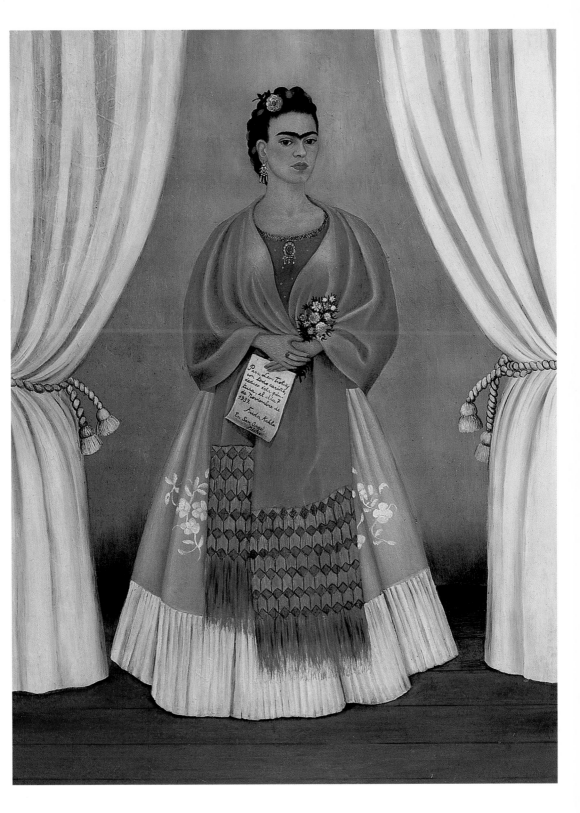

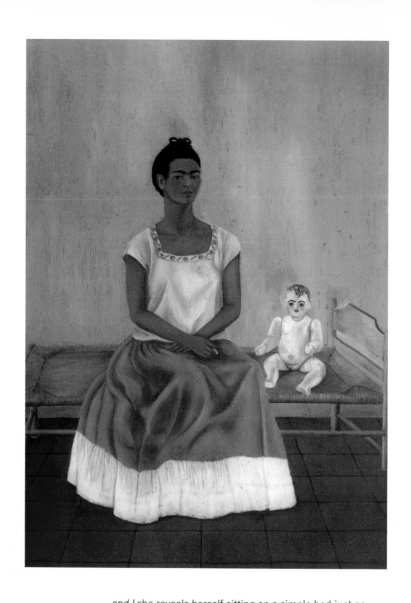

and I she reveals herself sitting on a simple bed just as stiff and straight as the doll next to her. Her knees are turned to the doll, which is slightly turned towards her. Yet, despite this suggestion of movement, there is no intimacy between the two, no relationship between them. Kahlo's lit cigarette underscores the void that separates them. Kahlo's sadness at being condemned to childlessness is also expressed in *Girl with a Death-Mask* (opposite). The mask worn by a child and the yellow flower she is holding in her hand are allusions to the Mexican 'Festival of the Dead', where they figure prominently on All Saints Eve. Dolores del Rio, to whom Kahlo gave the painting,

Frida Kahlo
*Self-Portrait Sitting on the Bed
or My Doll and I* 1937
Oil on metal
40 x 31 cm
Jacques and Natasha Gelman Collection,
Mexico City

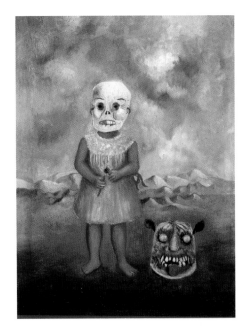

explains that the painter wanted to express 'her sorrow at the loss of a child'.[28] The themes of children and the death of a child re-emerge in *Dimas Rosas, Dead at Three Years of Age*. Here a boy is dressed like a saint in the Mexican funerary tradtion and is portrayed lying on the corn-husk mat that served the destitute as both a bed and a shroud. In this representation. Kahlo's reference is to the Mexican tradition of post-mortem portrait painting. The child lies there peacefully yet on the postcard, pain is identified symbolically with the scourging of Christ. *My Nurse and I* (also of 1937) was one of Kahlo's own favourites (see p. 60). She did, as we have seen, have an Indio nurse. In the painting the nurse is wearing a pre-Hispanic mask, which turns her into a stylized symbol of the indigenous Mexican culture which may be said to have nurtured Kahlo. Rain is falling from a bleak sky to make the earth arable. Originally Kahlo had short hair in this painting, which is why it has been interpreted as a reference to her lesbian side. Perhaps the reference was too bald-faced for her; she did repaint the hair to make it long.

In 1937–38 still lifes with flowers or fruits make their appearance in Kahlo's work. Towards the end of her life,

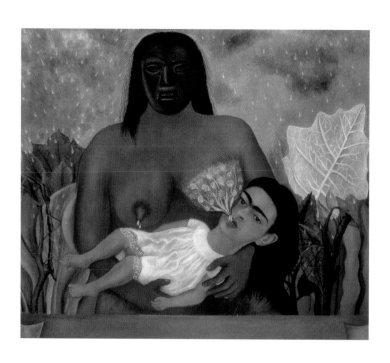

Frida Kahlo
My Nurse and I or Me Suckling 1937
Oil on metal, 30.5 x 34.7 cm
Dolores Olmedo Patiño Museum,
Mexico City

opposite page, top:
Frida Kahlo
Portrait of Diego Rivera 1937
Oil on panel, 46 x 32 cm
Jacques and Natasha Gelman
Collection, Mexico City

opposite page, bottom:
Frida Kahlo
Fruits of the Soil 1938
Oil on board, 40.6 x 60 cm
Banco National de México,
Fomento Cultural Banamex,
Mexico City

this genre predominated, becoming another form of self-portrayal. Her pictures of tropical fruits are obviously, even pointedly, sexual in character, and the fruit, usually sliced, recalls the painter's wounded body. *Fruits of the Soil* (opposite) is an especially erotic painting. In it the subjects painted recall genitals. This still life is dominated by the phallus-like stem of a mushroom. At the lower edge of the picture plane two mushroom caps symbolize breasts. What is striking about this composition is that it is, a rarity in Kahlo's oeuvre, in an outdoor setting.

In April 1939 André Breton and his wife, Jacqueline, came to Mexico The Trotskys, Bretons and Riveras became friends and undertook all sorts of joint activities. Kahlo is even said to have had an affair with Jacqueline. The Surrealist poet was himself a great admirer of Kahlo and her work. She did not return the sentiment. Breton said about the unusual painting *What Water Gave Me* (see p. 65), which is one of Kahlo's surrealist works: 'The picture which Frida Kahlo Rivera has just finished—*What Water Gave Me*—elucidates, unbeknown to her, the sentence I recently heard from Nadya's lips: "I am the thought above the bath in the room without mirrors."[29] That same year saw the completion

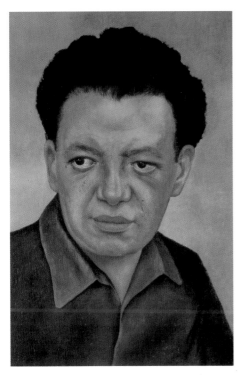

of Portrait of Diego Rivera, Kahlo's only portrait of the man she loved. Rivera himself received no commissions for murals between 1936 and 1940, and four portable wall panels for the Hotel Reforma were all he had to show for those years. The panels were never shown because of their implicit political content. Rivera was now devoting himself to panel painting. It is due to his encouragement that Kahlo participated in an exhibition mounted by the Mexico City University Gallery in 1938. To those in the know, this was an event of prime importance in the art world, the first time that Frida Kahlo had publicly exhibited work. When Kahlo made her first major sale, it was again her husband who arranged it.

Early in October 1938 Kahlo left for New York. There she prepared for her first one-woman show, which took place from 1–15 November at the Levy Gallery. Twenty-five paintings were shown and roughly half of them were sold. On the occasion of this show, Rivera wrote a letter to the

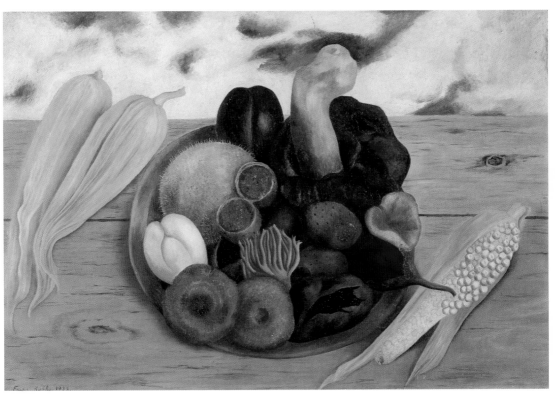

American critic Sam A. Lewisohn on 11 October 1939 in which the muralist's respect for his wife's work is apparent: 'I recommend her to you, not as her husband, but as an enthusiastic admirer of her work, which is astringent and delicate, hard as steel and as fine as butterfly wings, gentle like a lovely smile and as brutal as life is bitter'.[30] Kahlo enjoyed the freedom of New York and had several short affairs as well as a serious and passionate one with the photographer Nicholas Murray. But none of her admirers could hold a candle to Rivera, in her eyes at least. When Breton offered to organize a retrospective of her work in Paris for spring 1939, the painter hesitated at first because she seemed to want to return to her husband.
He, however, fondly encouraged her, in a letter written 3 December 1938, to work on her career: 'Don't be so silly as to miss such a great opportunity, just for my sake, of showing your paintings in a Paris gallery. Take advantage of anything life offers, whatever that may be, provided it's interesting and you enjoy it. (...) If you really do want to do me some good, remember that you cannot do anything that would bring me more pleasure than my knowing that you are happy (...). I cannot hold anything against anyone who likes such a Frida because I like her that way too, and more than anything else in the world (...).'[31]

Kahlo and Surrealism

In 1939 Kahlo did go to Paris, where she was to take part in an exhibition entitled *Mexique* at the Pierre Colle Gallery. Although she was a resounding success—Kahlo's jewelled hand graced the cover of *Vogue* and the doyenne of *haute couture*, Elsa Schiaparelli, created 'robe Mme Rivera' in her honour—Kahlo felt lonely. It was hard work mounting an exhibition and, into the bargain, she was struck down by a kidney infection. A letter to Murray is revealing, not only of her disgust at the way Paris intellectuals behaved but also at the overwhelming presence of Rivera in her life, since she, astonishingly, mentions her husband and her lover in the same sentence: '(...) You both live like parasites at the expense of a group of ostentatious

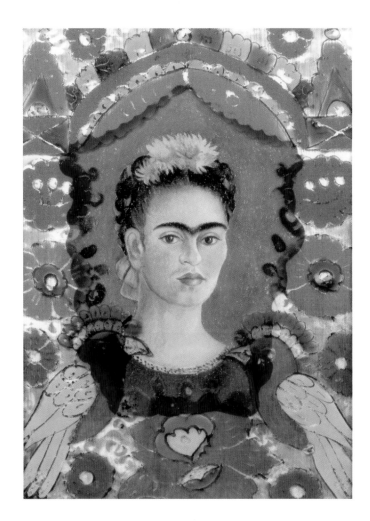

rich people, who presumably admire artistic genius. Shit, nothing but shit is what that is. I've never seen Diego or you wasting your time with empty chatter and intellectual discussions. That's why you are real men and not just pathetic "artists".'[32] Early in 1939 personal and political differences with Trotsky led Rivera to leave the IVth International, which Trotsky had founded in 1938 in Mexico. As soon as Kahlo heard about this, she sided loyally with her husband and, like him, distanced herself from Trotskyism. When journalists asked Rivera about his reasons for this step, he answered in his usual witty way: 'Because he wouldn't pay me any rent.' Kahlo maintained that Rivera had never heard about her affair with Trotsky and that the break had been purely political. Nonetheless, Rivera may well have got wind of what had gone on. Trotsky was deeply hurt by Rivera's decision and, only a few months later, moved out of the Blue House.

On 10 March the exhibition opened in Paris and the reviews of Kahlo's work were favourable. The Louvre even purchased one of her paintings, *The Frame*, a self-portrait. However, the exhibition was not all that successful financially because war threatened to break out. Kahlo's greatest fan was still her husband. '(…) Kandinsky was so moved by Frida's pictures,' Rivera said with pride, 'that he embraced her and picked her up right in public in the exhibition room. He kissed her on both cheeks and on the forehead and he

Frida Kahlo
Self-Portrait "The Frame"
c. 1938
Oil on aluminium and glass
29 x 22 cm
Musée Nationale d'Art Moderne,
Centre Georges Pompidou, Paris

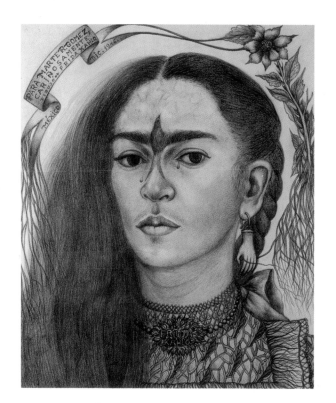

was so moved that tears were running down his face.'[33] Even the titan Picasso made Kahlo a present of a pair of earrings in the form of two hands, which she often wore and portrayed in works like the drawing *Self-Portrait Dedicated to Marte R. Gómez*. Rivera even worked the Picasso earrings into the fresco called *Panamerican Unity*. Picasso later wrote to Rivera: 'Neither Dérain nor you nor I can paint heads the way Frida Kahlo does.'[34] Rivera was especially proud of this remark of Picasso's.

While in France, Kahlo became acquainted with the leading exponents of Surrealism. She herself had joined their ranks by the time André Breton wrote a preface to the catalogue of her New York exhibition. 'How surprised and overjoyed I was to see, when I arrived in Mexico, that her work, although she was unaware of the reasons why my friends and I had gone there, to see that, with her most recent paintings especially, there she was, suddenly flourishing in the midst of Surrealism (...), writes Breton on her work at this time. 'I must add that no other painting is so essentially feminine, for she fluctuates between wide-eyed innocence and sheer depravity in order to appear as seductive as possible. Frida Kahlo Rivera's work is a coloured ribbon around a bomb.'[35] Bertram D. Wolfe entirely disagreed with Breton, writing in *Vogue* that, despite Breton's remark that she was a Surrealist, she in fact was unable to find her own style and wasn't helped any by trying out the methods of that School, '(...) Whereas mainstream Surrrealism was preoccupied with dreams, nightmares and neurotic symbolism, Mme Rivera's version of it was under the sway of wit and humour.'[36]

Kahlo was, in fact, a discovery of the Surrealists' and not one of them at all, as her biographer Hayden Herrera

Frida Kahlo
Self-Portrait Dedicated to Marte R. Gómez
1946
Pencil on paper
38.5 x 32.5 cm
Private collection, Mexico City

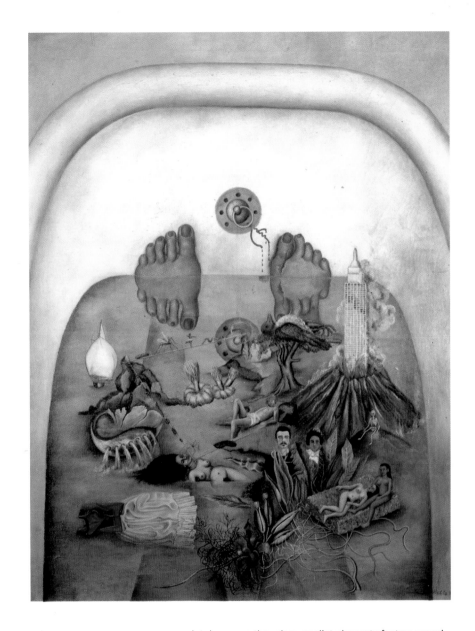

Frida Kahlo
What I Saw In The Water or
What Water Gave Me 1938
Oil on canvas
91 x 70.5 cm
Private collection

maintains, even though surrealist elements feature prominently in her work. Kahlo's most visionary, most irrational painting, which delves down deep into the subconscious with acute references to modern clinical psychology, is the above-mentioned *What Water Gave Me*. A sophisticated water fantasy, the painting is packed with symbolism on all planes, expressing self-pity and scorn, obsession and erotic fantasies. When the International Surrealism Exhibition opened on 17 January 1940 at the Galería

de Arte Mexicano in Mexico City, both Frida Kahlo, with her only paintings in large formats – *The Two Fridas* and *Wounded Panel* – and Diego Rivera were represented. His contribution was *Dr. Moore's Hands* and *Tree with Glove and Knife*. Presumably the latter two surrealist paintings owe something at least to Breton's influence, since Rivera's work is otherwise not surrealist. Incidentally, Rivera did not consider his wife a Surrealist any more than Wolfe did. He continually maintained her independence of art movements of any kind. Kahlo herself gives us what is perhaps the most unequivocal answer to the moot question of whether, and if so, to what extent her work may be accounted Surrealist: 'People thought I was a Surrealist. That's not right. I have never painted dreams. What I represented was my own reality.'[37]

On 25 March 1939 Frida went back to New York and Nicholas Murray, her confidence restored for the moment by her success in Paris. Her lover, however, ended the affair, leaving Frida Kahlo deeply hurt. A letter the photographer sent to the painter in Mexico in mid-May reveals his reasons for his decision: 'I was very much aware that New York could only temporarily fill up a void in you and I hope that you have returned home to find your safe haven unchanged. Of us three, you two were always a pair, I have always felt (...).'[38] By April Frida Kahlo had decided to return to Mexico after a separation of six months from Rivera.

Divorce and remarriage

On her return Kahlo did not find her safe haven unchanged. In summer 1939, she left the house she had shared with Rivera in San Angel and moved back into the Blue House since it was no longer occupied by Trotsky. It was Rivera who suggested a divorce and the couple were divorced on 6 November 1939. There are numerous theories on why this happened. It is always possible that Rivera had heard about her affairs with Trotsky and Murray and, even though this may not have been of prime importance, it may have

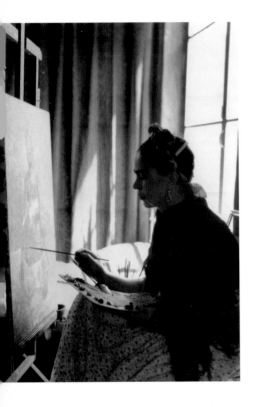

Manuel Alvarez Bravo took this photograph of Frida Kahlo while she was working on *Itzcuintli-Dog and I*. The painting was completed *c.* 1937. Photo: Manuel Alvarez Bravo

contributed to Rivera's decision. He was having an affair with the American screen actress Paulette Goddard. Perhaps the muralist simply wanted to be free to enjoy women without wrangling with a wife who had every right to be jealous despite her own extramarital liaisons. Kahlo later even became friends with Paulette Goddard, as she had done with so many of her rivals for Rivera's affections. In a letter written on 24 October 1940 to her friend Emmy Lou Packard, Kahlo went so far as to assert that Guadalupe Marín had been the grounds for divorce. Rivera had always had a particular feeling for Lupe. Many years after their divorce he painted the *Portrait of Lupe Marín* in 1938. Later Rivera was to write in his autobiography on the separation from Kahlo:

'I have never been a faithful husband, not even to Frida. Just as I did with Angelina and Lupe, I succumbed to temptation when it came my way and had quite a few adventures. When I saw Frida in such a bad state of health, I of course wondered whether I was really the right partner in marriage for her: I knew there wasn't much in my favour and at the same time it was clear that I would not be able to change much. (...) I loved her far too much to want to keep on inflicting more suffering on her. That is why I decided to divorce her. (...) she answered that she would rather endure anything at all than lose me entirely. (...) We had been married for thirteen years [in fact ten] and we still loved each other. All I really wanted was to be free to turn to any woman who took my fancy. (...) But wouldn't it have restricted my freedom to have allowed her to prescribe to me what I could and could not do? Or was I simply the dissolute victim of my own lechery? Wasn't it ultimately just a pretext that made me feel good when I thought that divorce would end Frida's sufferings? Didn't she in fact suffer more because of it?

During the two years we lived apart, Frida did some of her best work and thus sublimated her sorrow in painting.'[39]

This last assertion reveals a degree of complacency and selfishness. Rivera was making it easy for himself when he

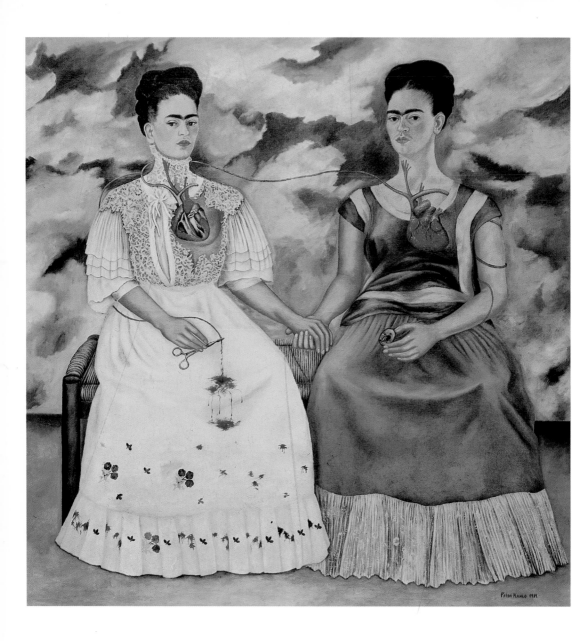

Frida Kahlo
The Two Fridas
1939
Oil on canvas
173.5 x 173 cm
Museo de Arte Moderno,
Mexico City

maintained he would never change and was the miserable victim of his own lust. To him the separation seemed necessary so that he could enjoy more freedom while helping Kahlo perforce to attain more independence. Yet Kahlo never wanted this kind of independence and suffered both physically and mentally from the separation. Afflicted with depression, she drank heavily. She had long been notorious for her ability to drink any man under the table. 'I used to

drink to drown my sorrow but now it's learnt how to swim',[40] she wrote as early as 1938 to Ella Wolfe. It is possible that she had to keep on increasing her alcohol intake to relieve excruciating physical pain. Kahlo now had a fungus infection in her right hand and the back pain caused by her spinal deformity had recurred. A pathetic photo taken by Nicholas Murray in September 1939 when he was in Mexico reveals Kahlo in an orthopaedic brace to stretch her spine. Here the mask of pride has been removed, leaving a face marked by sorrow and hopeless despair.

In *The Two Fridas*, which the artist painted soon after the divorce and which is arguably her best known painting, the artist has tried to come to terms with the separation from her husband. It comprises two self-portraits. The *Frida in Tehuana Dress* is the one loved by Diego Rivera and the other, in a white Victorian garment, is the one he spurned. The hearts of both are exposed to view, a direct expression of the painter's unhappiness over unrequited love. 'In the annals of art, Frida is the only person ever to have ripped open her breast and torn out her heart to tell the truth in biological terms and say what is felt inside,'[41] Rivera was to write four years later. The Frida adored by Rivera is depicted holding a portrait of her husband as a child. An artery grows out of it to feed both women. In her heart the artery divides and half of it goes to the rejected Frida, where it splits again. The artery is open-ended and the European Frida is trying to stop the blood flowing out of it with a surgical clamp but it keeps on dripping onto her white dress and Frida is about to bleed to death. This painting and *Two Nudes in the Wood* (see p. 70) — an unequivocal allusion to her bisexuality — were the only ones she attempted in 1939. However, in the following year Kahlo was again producing more work. By now she was eager to earn her own living by painting, claiming proudly: 'I won't take any more money from my husband as long as I live.'[42] She accepted some commissions, one of them from the art collector Sigmund Firestone, who had Frida Kahlo and Diego Rivera each paint a self-portrait. The portraits are in the same format and resemble each other in palette. Each contains a dedication on a piece of paper in the manner of

nineteenth-century Mexican portrait painting. A year later Rivera painted a nearly identical self-portrait: *Self-Portrait Dedicated to Irene Rich.* Kahlo's *Self-Portrait Dedicated to Sigmund Firestone* belongs to a series of portraits which reveal typological and stylistic similarities yet differ in details of composition. This series can again be read bio-graphically. Kahlo's face is haggard, she has dark circles round her eyes. Her face is mask-like, concealing profound sorrow which the spec-tator can only guess at. Defiant

above:
Frida Kahlo
Two Nudes in the Wood or The Earth or My Nurse and I 1939
Oil on metal
25 x 30.5 cm
Private collection

right:
Diego Rivera
Self-Portrait Dedicated to Irene Rich 1941
Oil on canvas
61 x 43 cm
Smith College Museum of Art,
Northampton, Massachusetts

Frida Kahlo
Self-Portrait Dedicated to Sigmand Firestone
1940
Oil on board
61 x 43 cm
Private collection, USA

protest has made Kahlo portray herself with short hair as she did in 1934. In showing herself thus she has not only inflicted self-injury but has tried to hurt her former husband, who loved her with long hair. Like attempted suicide, this is a deed done in despair, concealing a cry for help, attention and love. She wrote to Nicholas Murray on 6 February 1940: 'I have something awful to tell you. I've cut off my hair and look like an elf. Anyway, it'll grow again, I hope!'[43] In *Self-Portrait with Her Hair Cut Off* (see p. 72), Kahlo is seated in a chair, dressed in men's clothes, perhaps Rivera's, that are too big for her, with her hair cut off, and the weapon that

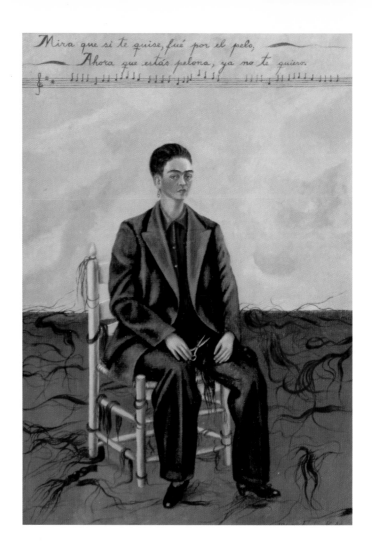

Frida Kahlo
Self-Portrait with Her Hair Cut Off
1940
Oil on canvas
40 x 28 cm
The Museum of Modern Art, New York
(Gift of Edgar Kaufmann Jr.)

opposite page:
Frida Kahlo
Self-Portrait with Plait
1941
Oil on board
51 x 38.5 cm
Jacques and Natasha Gelman Collection,
Mexico City

did the deed still in her hand. She looks depressed, staring reproachfully out at the spectator. With the exception of earrings and high-heeled shoes, all feminine accessories and attributes have been removed from this self-portrait. A photo taken in 1947 also shows Kahlo wearing trousers and similar shoes. The verse from a song visible at the upper edge of the picture is something Rivera might have said: 'Look, if I loved you, it was because of your hair; now you're shorn bald I don't love you any more.' Remarkably, this painting is the only one showing Kahlo in 1940 with short hair. All others she painted that year portray her with her hair put up on her head. She may have painted her portraits from photos. With the exception of G. Davila's photo, in which Kahlo's hair appears to have grown back,

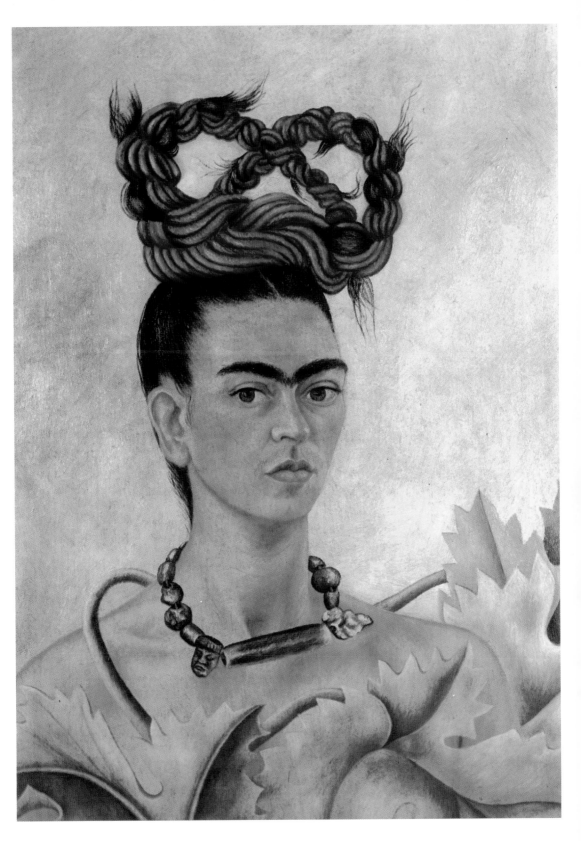

no photo is extant with the artist wearing her hair short. The following year, shortly before she and Rivera married for the second time, she symbolically reassumed her feminine attributes. In *Self-Portrait with Plait* (see p. 73) she seems to have woven the strands of hair she cut off into a sign of reconciliation. The odd-looking plait here is shaped like a pretzel.

In June 1940 Rivera went to San Francisco to paint a mural for the Golden Gate International Exposition. In late May an attempt had been made to assassinate Trotsky, who was to be the victim of a brutal murder on 21 August 1940. Rivera claimed he fled to the United States because he was suspected of being an accomplice. However, the offer of a commission had been extended to him by the United States long before. The mural Rivera painted in San Francisco is called *Panamerican Unity*. It comprises scenes taken from North American and Mexican history. The central panel, which deals with the fusion of the two cultures, contains a representation of Frida Kahlo in Tehuana costume. Rivera added this portrait of Kahlo after she joined him in San Francisco. In his view, she personified the 'cultural unification of the two Americas with the south winning out'.[44] On the right, behind Frida Kahlo, Rivera and Paulette Goddard, who, according to Rivera, represented the 'American girl (...) in ties of friendship with a Mexican man',[45] are planting the tree of life and love. This is not the first time that the muralist juxtaposed Frida Kahlo and one of his amours.

Frida Kahlo's health again grew worse and in September she went to San Francisco to be operated on by Dr Eloesser. He was the intermediary between Kahlo and Rivera, untiring in his efforts to make clear to her that Rivera would never change: 'Diego loves you very much and I know that you love him too. Naturally, and this is undisputed, Diego loves only two things besides you: first, painting and, second, women in general. He has never been — and will never be — the man to be permanently faithful to one woman, which is silly anyway and even unnatural.'[46] Moreover, the physician explained to Rivera that he regarded Kahlo's illness as resulting primarily from a nervous crisis brought on by

the divorce, and his recommendation was remarriage. On 8 December 1940, the muralist's birthday, Frida Kahlo and Diego Rivera were remarried. Kahlo had made re-marriage contingent on several conditions. 'She wanted to be fully financially self-sufficient through her own efforts,' reported Rivera in his autobiography 'and live from what she earned by selling her work; I was to foot half the household expenses, nothing more; there were to be no sexual relations. She explained this condition by saying that it was impossible for her to overcome the psychological barrier which went up whenever she thought of all my other women. I was so overjoyed to have Frida back again that I agreed to everything.'[47]

However, according to reports, neither of the terms agreed on was ever fulfilled.

'Los Fridos' and 'Los Dieguitos'

When Frida Kahlo returned to Mexico at Christmas 1940, she was more self-assured and independent than ever before. Now she set her own standards. From now on she would no longer leave the Blue House, which became her hermetic universe. With the exception of a stay in New York, where she underwent an operation in 1946, she took no more trips abroad. After finishing his work in the United States, Rivera moved to Coyoacán to be with his wife. From now on he only used the house in San Angel as a studio and retreat. Rivera was now working mainly at the easel, yet he began on a fresco cycle, *Precolonial and Colonial Mexico* in the first storey of the National Palace inner court. He finished it in 1951. That same year he undertook to build Anahuacalli, investing every peso he could spare in it and working on it until his death. Anahuacalli is an an-thropological museum which was to house Rivera's com-prehensive collection of precolonial artefacts. It did not open its doors to the public until 1964. The lava plain of the Pedregal region on which the museum was built first appears in Frida Kahlo's work in *Roots*, painted in 1943. It resurfaces quite often in the background of her later work.

The first half of the 1940s saw Frida Kahlo consolidating her success. She took part in numerous exhibitions in Mexico and the United States, joined a variety of cultural organizations and accepted commissions for portraits. *The Portrait of Doña Rosita Morillo* (see p. 79), commissioned by Eduardo Morillo Safa, a patron of the arts, was one of Kahlo's favourites. She began to paint more half-length portraits, which were easier to sell than full-length ones which tended to deter clients. Her husband, too, achieved increasing recognition. In 1943 President Manuel Avila Camacho appointed Rivera and José Clemente Orozco as official representatives of the fine arts.

That year Frida Kahlo and Diego Rivera were both appointed to teach at the Academy of Painting and Sculpture, which had opened in 1942. The school was called 'La Esmeralda' by its students because it was originally located in the street of that name. This was Rivera's first teaching post since he had been forced to resign from the directorship of the San Carlos Art Academy in 1930. Frida Kahlo started off teaching in the Academy building but for health reasons soon transferred her classes to the Blue House. However, many students found the long trip to Coyoacán too much of a bother. The only ones left to Kahlo after a short time were Arturo García Bustos, Guillermo Monroy, Artural Estrada and Fanny Rabel. This close-knit group of pupils was known as 'Los Fridos'. Rivera's pupils styled themselves 'Los Dieguitos'. The Riveras undertook

Frida Kahlo and Diego Rivera in the dining room at the Casa Azul. The way they are holding each other and the protective hand on Diego's head underline the extent to which Kahlo had become both a partner and mother figure to Rivera. Photo: Emmy Lou Packard, with the kind permission of Don Beatty

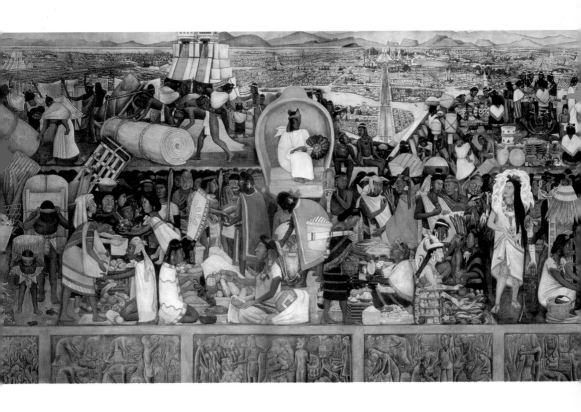

Diego Rivera
The Large City Tenochtitlán, from the cycle:
'Precolonial and Colonial Mexico'
1945
North wall. 4.92 x 9.71 m
National Palace, Mexico City

excursions with their pupils, visiting markets and neighbouring cities to teach them how to draw inspiration from scenes of everyday life and, of course, to appreciate the natural beauty of their country. After Kahlo's death, Rivera was to write: 'She taught pupils who today are among the leading members of the present generation of Mexican artists. She always insisted on their retaining their own personality in their work and developing it further and at the same time expressing in it their social and political ideas.'[48] 'Frida allows her students to find their own work rhythm and sharpens their sense of self-criticism. Unlike her husband, she "never said a word about how we were supposed to paint or questions of style, as we were accustomed to hearing from Diego Rivera,"' said Arturo García Bustos.[49] Fanny Rabel told us about the different approaches to teaching employed by the Riveras: 'Rivera could develop a theory from absolutely anything in no time at all; the maestra, on the other hand, was intuitive and spontaneous.'[50] Frida Kahlo arranged for her students to decorate the facade of the *pulquería* (a tavern serving

nothing but pulque, spirits distilled from agave) 'La Rosita' in oils, thus giving them an opportunity of learning something about mural painting. To Rivera, painted *pulquería* facades represented the most Mexican of all vernacular art forms and he attributed to this genre the rise of mural painting in Mexico. The Riveras ensured that materials were provided and helped their pupils with advice. The dedication of the facade was a social event and further projects followed.

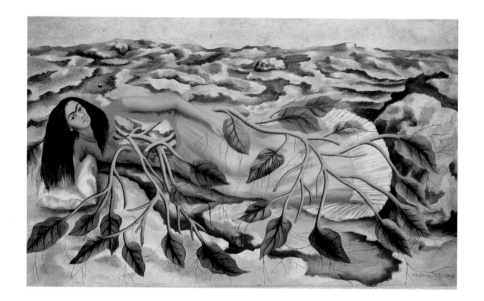

From wife to mother — from husband to child

above:
Frida Kahlo
Roots or The Pedregal
1943
Oil on metal
30.5 x 49.9 cm
Private collection, Houston, Texas

opposite page:
Frida Kahlo
Portrait of Doña Rosita Morillo
1944
Oil on canvas, mounted on board
76 x 60.5 cm
Dolores Olmedo Patiño Museo, Mexico City

From 1944 Frida Kahlo began to reduce her teaching activities for health reasons. She was made to spend a good deal of time in bed and had to wear a steel brace. She was to wear 28 different braces during the last years of her life. She lost her appetite and grew very thin. There has been quite a lot of speculation about whether Kahlo's physical suffering and the many operations she endured were not basically a means of tying her husband closer to her. Her favourite physician, Dr Eloesser, even went so far as to express the opinion that many of the operations were unnecessary. In those years Kahlo painted a series of

self-portraits in which she represented herself as ill and suffering. The first of these was *Broken Column* (1944). Here the artist has portrayed herself as a nude in an upright posture. A white cloth which she holds in her hand covers the lower part of her body. Only one fingernail, which appears to sport nail varnish, is visible. This detail contrasts strongly with Kahlo's usual looks in her self-portraits, where she is otherwise rarely depicted wearing jewellery and make-up. The loincloth is an obvious reference to Christian iconography. So are the nails which are stuck in the head of the subject, recalling St Sebastian pierced by arrows. Kahlo's body is torn open from the waist up to reveal a broken Ionic column in it. Her body is held together by an orthopaedic corset of the type the artist had to wear the year she executed this particular painting. Tears trickle out of her sad, slightly reddened eyes. This is a portrayal of pain endured with quiet resignation. Another work of this period is *Without Hope*, which alludes to the diet she had been prescribed to make her gain weight. She found it disgusting. *Tree of Hope Keep Strong* (see p. 82), the third in this group, was painted after Kahlo had had a serious spinal operation in New York in 1946. This is a double

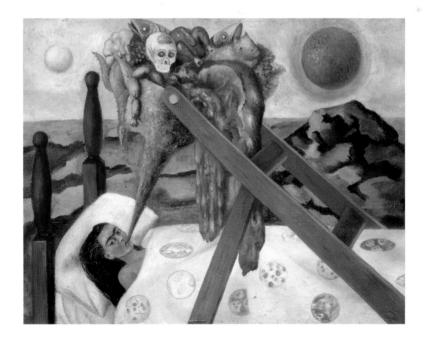

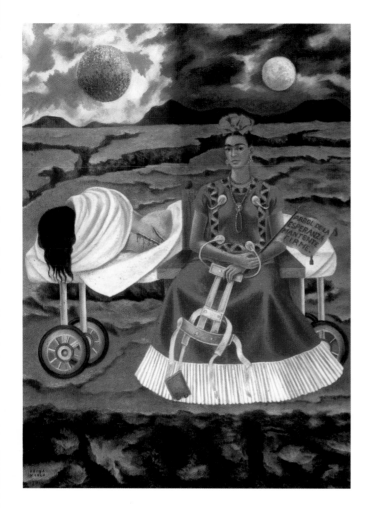

self-portrait, divided into two halves, and the dualistic principle features consistently throughout. On the left the painter has represented the masculine heavenly body, the Sun. This is the wounded half, turned to Rivera. The right side represents the female half, the night with the moon. The artist has portrayed herself as a brave woman even though a tear trickles from her right eye. In *Wounded Stag* of the same year, a stag with magnificent antlers leaps through a wood. His head is Kahlo's, wearing an earring. Again, like St Sebastian, the animal is pierced with arrows and blood drips from its wounds yet, defying gravity, this painting is distinguished by a certain lightness.

In September 1946 the artist received an award for *Moses* (see pp. 84–85) at the art exhibition held annually by the Palacio de Bellas Artes. Despite her fragile health, she was there to receive her award in person. *Moses* is a dense picture allowing much scope for interpretation, packed with real and mythical figures related to the theme of Moses. On one plane it represents a searching study of the poetic implications of reproduction as part of the cycle of life. José Domingo Lavin, a patron of the arts, had lent Frida Kahlo Sigmund Freud's *Moses and Monotheistic Religion*. She was so enraptured with it that she completed the work inspired by it and commissioned by Domingo Lavin in only three months. Frida Kahlo was to explain in a lecture:

'I only read the book once and started painting under the influence of a first impression. Yesterday I reread it and

Frida Kahlo
Tree of Hope Keep Strong
1946
Oil on board
55. 9 x 40.6 cm
Private collection

I must admit that the painting now seems really inadequate (...). However, now I can't change or add anything and so I'll simply have to accept the picture as it is and as you see it. Its real theme is, of course, Moses, or rather, the birth of the hero but I have generalized the facts and pictures from the book which impressed me while I was reading it in my own (very confused) way. You can tell me whether I was wrong or not. What I particularly wanted to emphasize very clearly is that pure fear is what drives human beings to invent heroes and gods or to imagine them. Fear of life and fear of death (...). At bottom centre is what is most important for Freud and many others: Love, represented by a shell and a snail, the two sexes surrounded by always new and living roots. (...)'.[51]

The main figure is, therefore, Moses, whose facial features noticeably resemble Rivera's. As in other Kahlos, he is portrayed with a third eye that can see into the future on his forehead.

In the 1940s Rivera's face often figures prominently in Kahlo's work. After they remarried, the roles played by each in the marriage underwent a striking change. Kahlo had become more independent and more particular about

Frida Kahlo
Wounded Stag or The Little Stag
1946
Oil on board
22.4 x 30 cm
Private collection, Houston, Texas

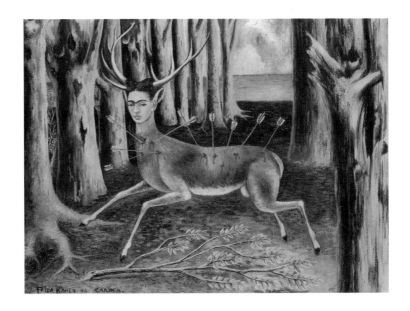

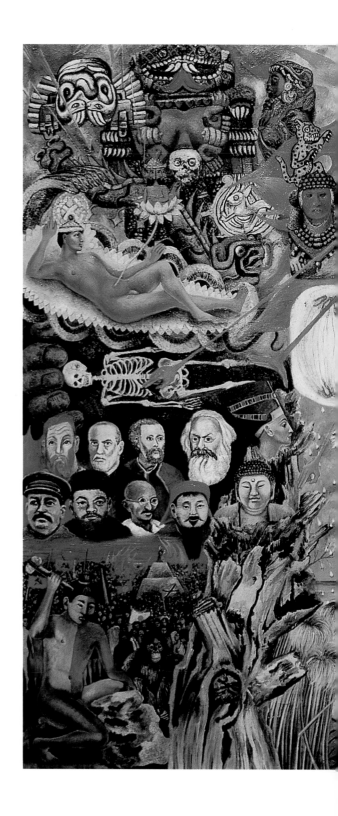

Frida Kahlo
Moses
1945
Oil on board
61 x 75.6 cm
Private collection, Houston, Texas

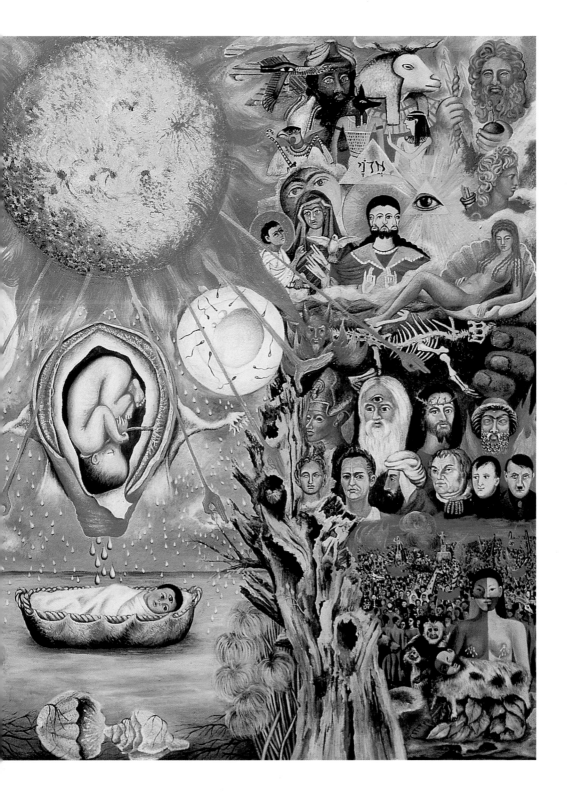

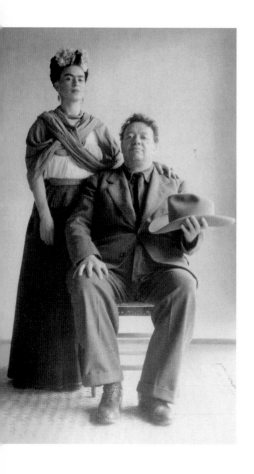

Frida Kahlo and Diego Rivera. c. 1940 in
San Francisco, where the couple married
a second time on 8 December.
Photo: Nickolas Muray, International Museum
of Photography, George Eastman House,
Rochester, New York

what she would take from her unpredictable and selfish
husband. She tried hard to react more casually to his
escapades, assigning to herself the role of the protective,
warm yet dominating mother. Rivera had long since ceased
to be merely the great model of the artist and man whom
she had looked up to in submissive admiration as a daughter
might to a father. In one photo taken at their first wedding,
Rivera stands next to Kahlo, who is seated, with a fatherly
arm about her shoulders. A photo taken in 1940, on the
other hand, shows them in a reversal of positions and roles:
Rivera is now seated, albeit looking far more assertive
than the shy Frida of the earlier picture, and his wife is
now standing, with her hand resting on his shoulder. The
two photos shed a great deal of light on the role reversal
that had taken place during the second marriage. The first
painting representing Rivera and Kahlo executed after
the 1931 wedding picture—except for *The Two Fridas*—is
called *Diego in my Thoughts*. Kahlo is portrayed wearing
her Tehuana dress; her face is hieratically framed by a
wreath of lace. A portrait of her husband, gazing off into
the distance, replaces on her forehead the third eye of
wisdom. Rivera has been portrayed in this painting ob-
sessively, as indeed he most likely was the centre of
Kahlo's life and thought. If this had not been the case,
she would not have bound herself to this self-centred
man all her adult life. Another picture which portrays
the couple together is *Diego and Frida 1929–1944 (I)/(II)*.
Kahlo gave this painting to her husband in 1944 as a
present on their fifteenth wedding anniversary. Half of
each of the two faces, Kahlo's and Rivera's, is shown
merging into one head. Kahlo's head is smaller than that
of her husband but her hair, put up on her head, matches
Rivera's in circumference. Their chins do not fuse com-
pletely. Rivera's face is smiling good-naturedly; Kahlo,
however, has portrayed herself as serious, even sad,
perhaps because they lived apart for most of 1944. Kahlo
never did portray herself really smiling; even in her earliest
self-portraits only the corners of her mouth turn up slightly.
She is rarely shown laughing in photos, not because she
didn't love to laugh, but simply because she wanted to hide
her bad teeth. In the above double portrait, twigs twine

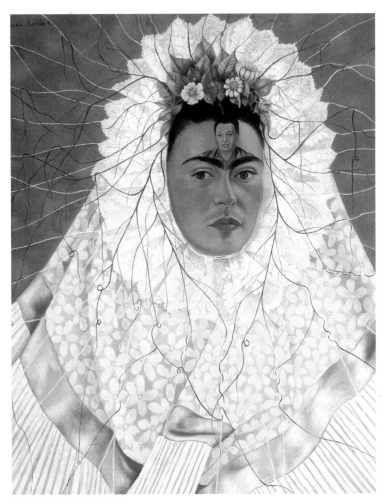

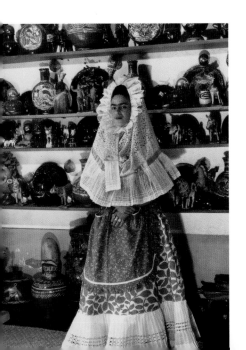

about the necks of the couple, linking them inextricably. The sun and moon, as well as the snail and shell, which are also glued to the frame, symbolize transparently the male and female element. The painter must have been expressing a romantic desire to become one with her husband yet this doesn't look much like a really harmonious fusion of two natures.

Another painting overloaded with sex symbols is *The Sun and Life* (see p. 88). The Sun, male power and the symbol for Rivera, is life-giving and bears the third eye at the centre. Plants shaped like the labia of the vulva and ejaculating phalli twine around it formlessly. The drops of semen are

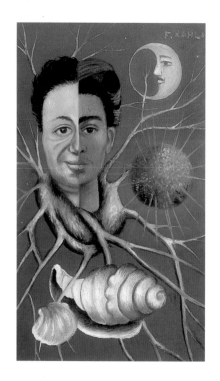

configured like the tears flowing from the eye of wisdom and the eye of the embryo. Representing a paean to life, the work also expresses the painter's sorrow that she was unable to bear children.

The painter as subject has also been represented with a sad face in *Diego and I*. Her hair twines about her throat as if about to choke her. Kahlo rarely portrayed herself with her hair loose. One of her most impressive self-portraits is *Self-Portrait with Hair Down*. As in the earlier *Diego in my Thoughts*, Rivera is enthroned on her forehead. Kahlo presumably portrayed herself in tears because her husband was having an affair at the time the picture was painted, with the famous film actress María Félix. Rivera was not the man to deny that 'like so many thousands of Mexicans, he, too, was in love with her.'[52] Rumour had it that he even wanted to marry Félix, and years later the muralist's comment on the subject was: 'After Frida's death I admired, esteemed and venerated no one in the world more than María. I don't believe anyone loved her more than I, no one.'[53] No wonder that Kahlo was jealous, even though she pretended that her husband's veneration of the actress made no difference to her. Kahlo's strategy for countering the María affair was to become friends with her.

Frida Kahlo
Diego and Frida 1929–1944 (II) or
Double Portrait, Diego and I (II) 1944
Oil on board
13.5 x 8.5 cm
Private collection, Mexico City

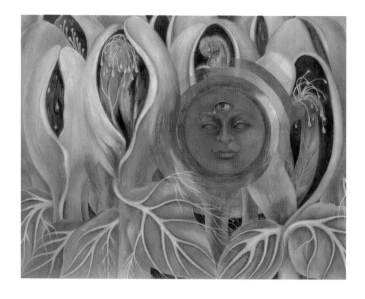

Frida Kahlo
The Sun and Life
1947
Oil on board
40 x 50 cm
Private collection, Mexico City

Frida Kahlo
Diego and I
1949
Oil on canvas, mounted on board
28 x 22 cm
Private collection

Kahlo developed a more or less motherly relationship with her husband in order to come to terms with his infidelities. She began to keep a diary in 1944 and continued to do so for the rest of her life, an invaluable source of information on her thoughts and feelings. She wrote: 'He's my child every minute, my newborn, every minute of the day, my very own.'[54] As a mother holds her child, Kahlo portrayed herself cradling her husband in her arms in *The Embrace of Love of the Universe, The Earth (Mexico), I, Diego and*

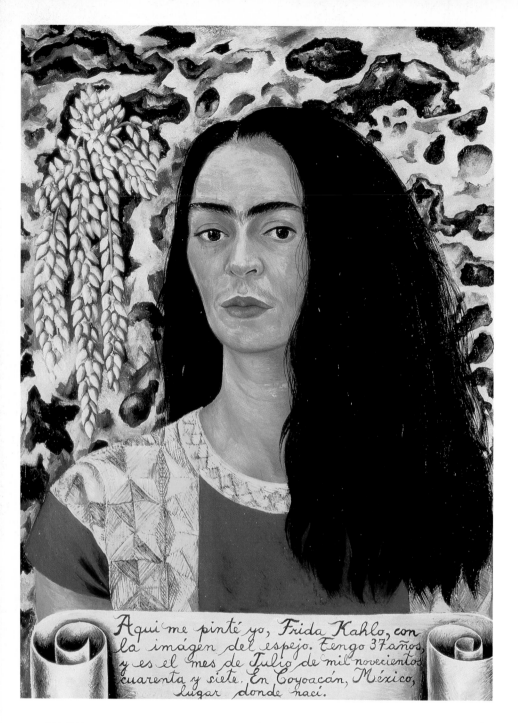

Aqui me pinté yo, Frida Kahlo, con la imágen del espejo. Tengo 37 años, y es el mes de Julio de mil novecientos cuarenta y siete. En Coyoacán, México, Lugar donde nací.

Frida Kahlo
Self-Portrait with Hair Down
1947
Oil on board
61 x 45 cm
Private collection

opposite page:
Antonio Kahlo, Cristina Kahlo's son, took this photograph of his aunt, Frida Kahlo, showing her dressed in a Chinese pyjama suit. This is one of the few pictures of the artist with her hair let down.
Photo: Antonio Kahlo, 1947, in Coyoacan, with the kind permission of Cristina Kahlo, Mexico City

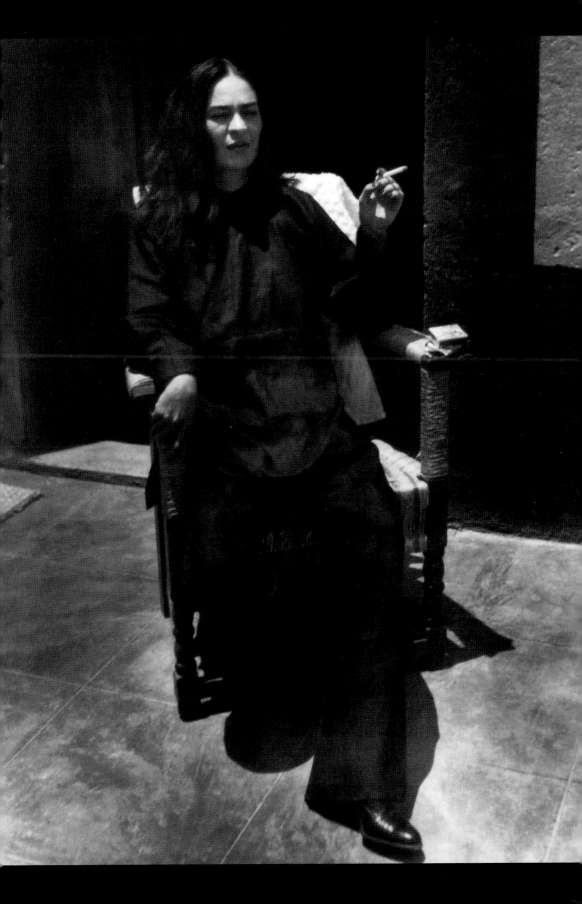

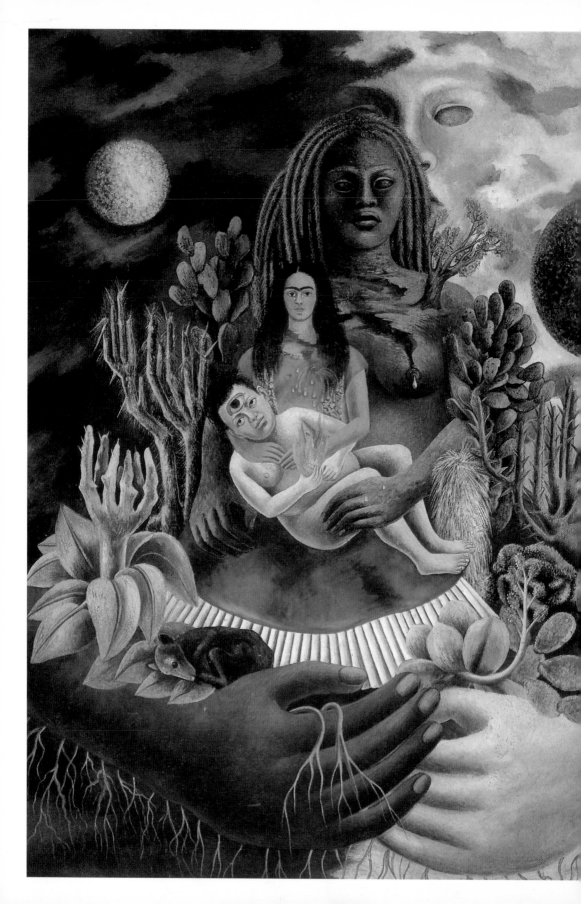

Frida Kahlo
*The Embrace of Love of
the Universe, The Earth
(Mexico), I, Diego and
Sr Xólotl* 1949
Oil on canvas
70 x 60.5 cm
Private collection,
Mexico City

Sr Xólotl. Kahlo is shown being embraced by Mother Earth
and she in turn by the Universe, which protectively envelops
them all, including Sr Xólotl, Kahlo's favourite dog. There is
a drawing in her diary which she used as a preliminary
study for this painting. Elsewhere in her diary it is obvious
that Rivera meant not only a child to her; he was her entire
universe, everything she had.

Diego beginning
Diego founder
Diego my child
Diego my darling
Diego painter
Diego my lover
Diego 'my husband'
Diego my friend
Diego my mother
Diego my father
Diego my son
Diego = I =
Diego universe
diversity in unity
Why do I call him my Diego? He has never been,
and never will be, mine. He belongs to himself.[55]

On the occasion of a comprehensive and highly successful
retrospective of Rivera's work, mounted in 1949 by the
Palacio de Bellas Artes to celebrate fifty years of painting,
Frida Kahlo contributed an article to the catalogue, which
she called 'Portrait of Diego'. In it she described her hus-
band as she had painted him in the portraits mentioned
above:

With his Asiatic-looking head with the dark hair growing
on it so thin and fine that it seems to be floating in the air,
Diego is a giant child, with a friendly face and a rather sad
look. His prominent, dark, highly intelligent, big eyes are
seldom still (...). Between these eyes (...) one can guess at
the invisible of Oriental wisdom, and only seldom does
the ironical and delicate smile, the flower of his portrait,
disappear from his Buddha-like mouth with its fleshy lips.

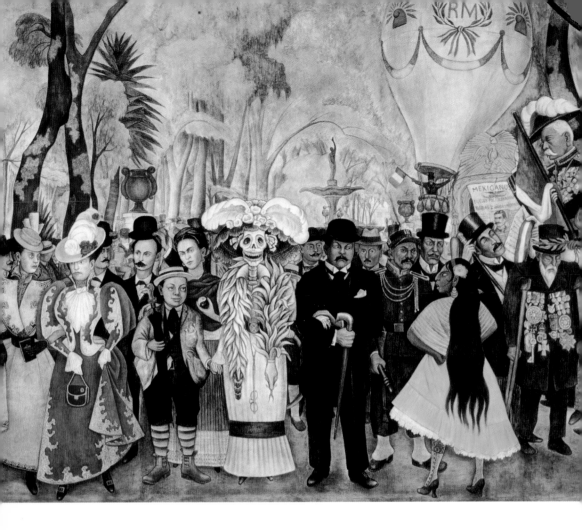

Diego Rivera
*Detail, from: Dream of a Sunday Afternoon
in Alameda Park* 1947–48
Fresco
4.80 x 15 m
Diego Rivera and Frida Kahlo Museum,
Mexico City

If you see him naked, you immediately think of the frog boy, standing on his hind legs. His skin is greenish white like that of an aquatic animal. Only his hands and face are darker because the Sun has tanned them. His childish, narrow and round shoulders merge into feminine arms to end in wonderful, little, delicately formed hands which, sentient and sensitive, communicate with the entire universe like antennae.'[56]

Frida Kahlo wasn't alone in placing him in a mother-son relationship within their marriage. Rivera acquiesced in this role. In 1947 Rivera began painting a fresco, *Dream of a Sunday Afternoon in Alameda Park* in the Hotel del Prado. This is Rivera at his most autobiographical, his last, great history fresco. Its subject matter ranges from the Spanish

Conquest to the Mexican Revolution. Unusually for Rivera, the work is suffused with a golden yellow tone, which enhances the dreamlike quality of the fresco. It soon caused an uproar, since Ignacio Ramírez, who had supported the separation of church and state under Benito Juaréz, is depicted holding up a sheet of paper with 'God does not exist' written on it. The fresco was covered and not exposed to public view again until 1956, after Rivera had replaced the controversial declaration with a different inscription. At the centre of the fresco, Rivera portrayed himself as a boy holding an umbrella and a frog and a snake in his pockets. His left hand is clutched by the 'Calavera Catrina', a caricature of a skeleton representing the haughty bourgeoisie. It can also be read as a reference to the Aztec Earth Mother, Coatlicue. To the right of 'Catrina' is her creator, the graphic artist José Guadalupe Posada, whom the muralist revered. Rivera modelled his Catrina figure on Posada's caricatures Behind Rivera stands Frida Kahlo, her motherly hand on his shoulder. In her other hand she holds the Yin-Yang symbol signifying the dualistic principle. Rivera painted this portrait of Kahlo from a photo taken by Nicholas Murray ten years before. This is definitely one of Rivera's finest portraits of his wife.

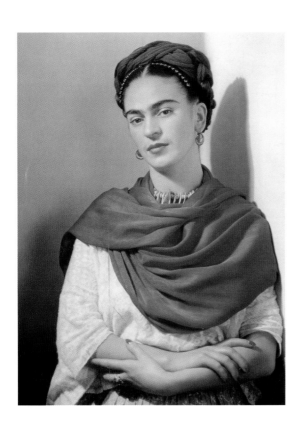

Frida Kahlo, 1938/39, by Nickolas Muray. At the time of this photograph Muray and Kahlo were lovers.
Photo: Nickolas Muray, International Museum of Photography, George Eastman House, Rochester, New York

Kahlo in terminal decline

In 1950 Kahlo's health deteriorated to the point that she had to spend an entire year in hospital in Mexico City. She underwent seven spinal operations. Not until November of that year was the artist able to paint and she did so lying in bed, executing *The Kahlo Family Portrait* (see pp. 96–97). Her husband took a room next to hers while she was working on it and often spent the night in the hospital. He was quite attentive to her yet he wasn't always really supportive when she needed him to be, which made Kahlo's condition worsen. 'The fluctuations

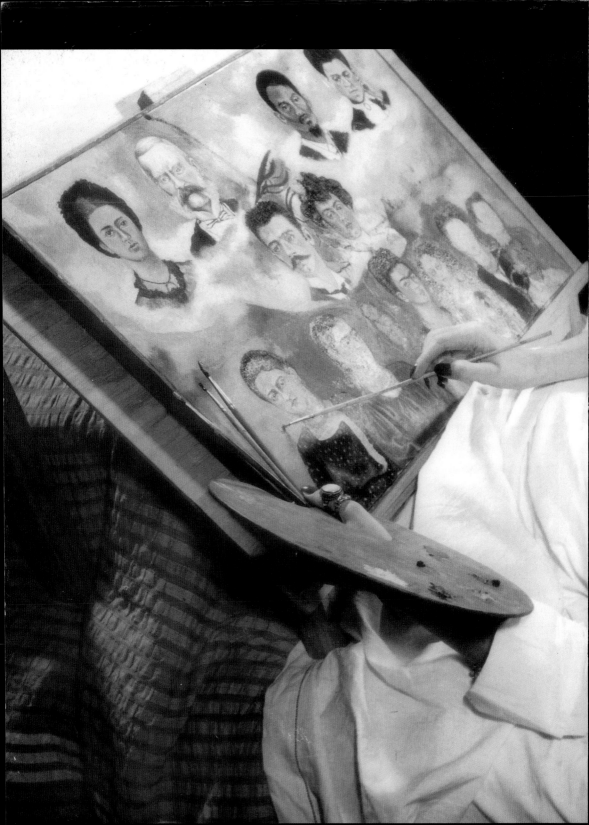

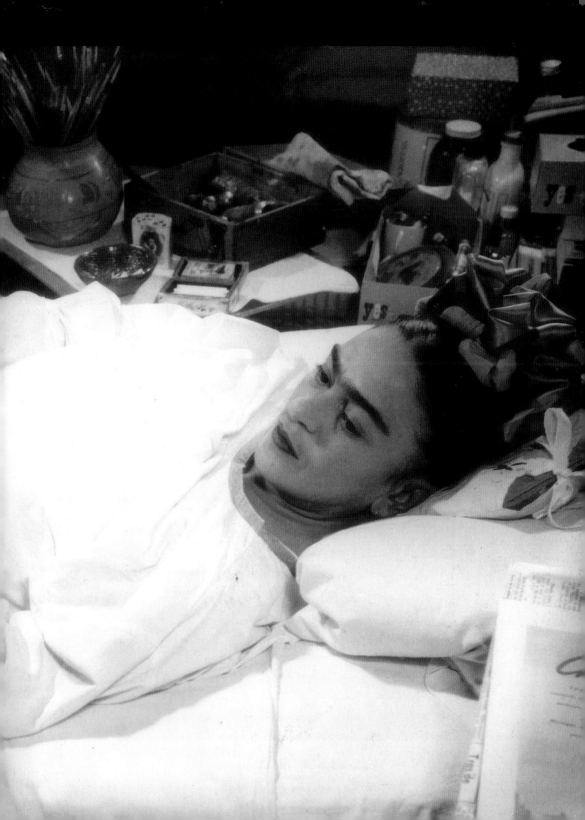

in her health while she was in hospital', reported Dr. Velasco y Polo, 'depended entirely on Diego's behaviour. She could not lay her pain at the feet of the Blessed Virgin so she spread it out at Diego's. He was her Saviour.'[57] This was a highly productive year for Rivera. He collaborated with Siquieros on illustrating a limited edition of the long verse epic *Canto General* by the Chilean poet Pablo Neruda and designed the cover. Rivera also continued to work on his frescoes in the National Palace. In addition, he represented Mexico at the Venice Biennale, together with Siqueiros, Orozco and Tamayo, and was awarded the 'Premio Nacional de Artes Plásticas' in Mexico. The following year Rivera

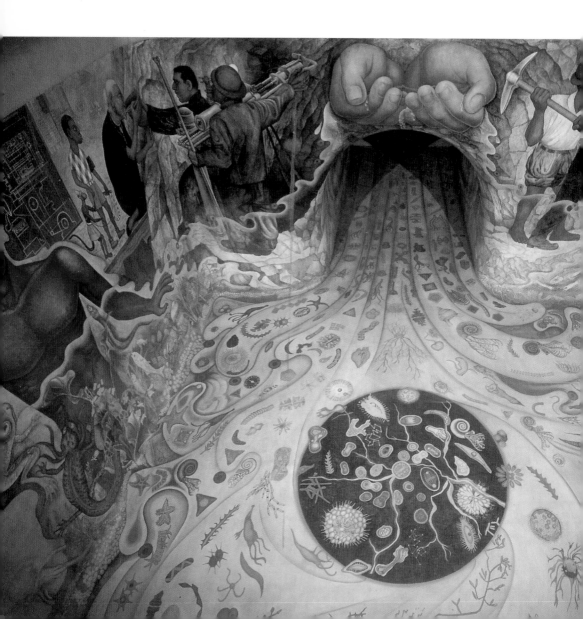

Diego Rivera
Detail, from: *'Water, Origin of Life'* 1951
Fresco cycle, polystyrene and liquid rubber
Cárcamo del río Lerma, Chapultepec Park,
Mexico City

executed a mural in polystyrene in the water well at
Chapultepec Park in Mexico City: *Water, Origin of Life.*
He also designed a fountain with a mosaic of natural
stones in front of the building with the water well. The
mural is a handsome allegory of water as the indispensable
giver of life without which human existence is impossible.
Two vast hands scoop blue water in front of the basin above
the well. The surface covered by water is thronged with the
organisms that live in this element. The rest of the building
is covered with scenes showing how humankind uses water.
Clear pastel colours and the apt translation into visual and
aesthetic terms of the dynamic of flowing water make this
a striking achievement. Rivera experimented with new
pigments which were supposed to be water-resistant.
Unfortunately, the colours deteriorated in less than five
years. Rivera was also commissioned to decorate the outer
shell of the university sports stadium with murals. By 1953
he had finished the front facade, a mosaic relief in natural
stone, and had even found time to execute a glass mosaic
mural on the history of Mexican theatre for the facade of
the Teatro de los Insurgentes.

After a year spent in hospital, Kahlo was again at home in
Coyoacán in 1951. However, she was by now very weak and
needed constant care. She painted a portrait of her father,
who had died in 1941, and, in appreciation of his care, *Self-
Portrait with a Portrait of Dr Farill* (see p. 100), dedicated
to her personal physician. The painting is like a devotional
image with the doctor replacing the saint as intermediary
and Saviour in time of need. She has portrayed herself
holding a heart instead of a palette. On the portable wall
panel *Nightmare of War, Dream of Peace* (see p. 101), Rivera
painted his wife in the same pose and clothing collecting
signatures for the Stockholm appeal for peace. The panel
was to accompany the exhibition 'Twenty Years of Mexican
Art' to Europe. However, the work was not shown be-
cause, always the politically committed painter, Rivera
had portrayed Stalin and Mao Tse-tung in it. Again and
again he managed to become involved in the fray at the
very epicentre of public debate because his murals were
so politically controversial, and this uncompromising

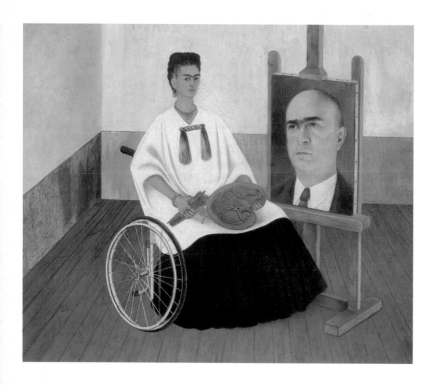

Frida Kahlo
Self-Portrait with a Portrait of Dr. Farill
or Self-Portrait with Dr. Juan Farill 1951
Oil on board, 41.5 x 50 cm
Private collection, Mexico City

opposite page:
Frida Kahlo and Diego Rivera in front of Diego's
work Nightmare of War, Dream of Peace in 1952.
Diego Rivera painted this mural in the Palace of
Fine Arts. Frida Kahlo, who at this time was bound
to a wheelchair, posed for him as a model.
Photo: Juan Gunzman, 1952. Archivio CENEDIAP-
INBA, Mexico City

aesthetic stance is what made him so famous. By 1948 Frida Kahlo had been received back into the Mexican Communist Party. Early in the 1950s politics began to assume ever greater importance in her life. Indeed, her solidarity with communism even took on a religious fervour. Kahlo yearned to serve the cause of the Revolution with her painting. 'I'm very uneasy about my painting,' she wrote in her diary in 1951, 'particularly since I want to turn it into something useful, for up to now all I've done with it is to express myself, which, unfortunately, has been of no use whatsoever to the Party. I must fight with all the strength I have to ensure that the little positive effort my illness allows me also serves the Revolution. That is the only real reason for living.'[58] Like her husband, she too portrayed Stalin in her work towards the end of her life and, as in Rivera's work, the dove of peace appeared in her still lifes. For all that, Kahlo's political commitment was not nearly as strong as husband's, whom one is certainly justified in calling a painter of the Revolution. Kahlo once admitted to Raquel Tibol, her biographer: 'My painting isn't revolution-ary. Why should I fool myself into thinking that it's militant; I can't do that.'[59]

From 1951–52, Frida Kahlo's work underwent a noticeable stylistic transformation. After she was discharged from hospital, she reverted increasingly to the still life, virtually neglecting the self-portrait as a genre. However, her still lifes were now both coarser and more nervy than her earlier

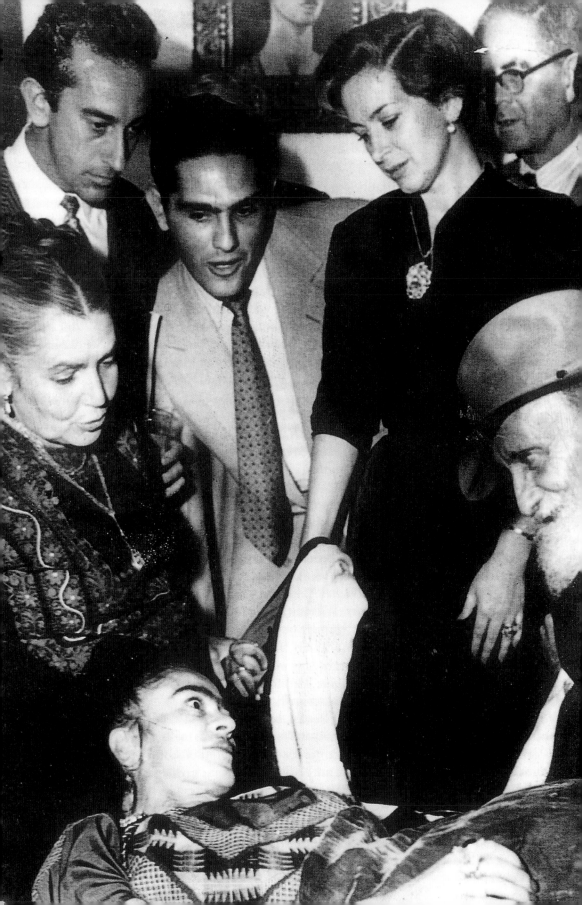

ones had been and her palette was more aggressive. Her
brushwork became thick and paste-like, applying ever
heavier coats of paint. The reason for this change in style
and technique may well be that she was by now always
under strong medication and, in addition, continued to
drink. Constricting fear is the keynote of these paintings.
Torn fruits recall her wounds, trickling juice connotes
tears. Kahlo became increasingly isolated, her husband
now spent little time with her. 'They lived under one roof
but separately,' recalls a nurse who took care of her. Kahlo
even made several attempts at suicide, probably to call
attention to her suffering and ultimately to her existence.
In December 1952 she seemed to enjoy a brief respite
from gloom. While she was restoring *La Rosita*, a mural,
she showed that she had never entirely lost her sense of
humour because she chose María Félix and her husband
as the centrepiece of a new painting.

Viva la vida — Kahlo's death

April 1953 saw Frida Kahlo's first one-woman show in
Mexico, at the Galería de Arte Contemporáneo, owned
by Lola Alvarez Bravo. Kahlo came to the opening in an
ambulance and was carried in on a stretcher. Her four-
poster bed had been set up in the gallery, as an integral
element of the exhibition. However, the focus of attention
that evening was not so much the retrospective of her work
as the artist herself. Her appearance amounted almost to
exhibitionism. 'Everything was rather too shrill,' recalled
Raquel Tibol, 'almost like a Surrealist event. Frida played
the Sphinx of the Night by taking to her bed in the gallery.
It was self-dramatization at its most theatrical.'[60] Rivera,
on the other hand, saw the whole show as the event of
the year. 'Even I was impressed when I saw her oeuvre,'
the muralist wrote in his autobiography, looking back
on that evening, '(...) Frida remained seated in the room,
quiet and content, happy that so many people had come
to honour her with such enthusiasm. She hardly said
a word but I said to myself later that she must certainly
have realized that this was her farewell to life.'[61]

Pies para qué los quiero
Si tengo alas pa' volar.
1953.

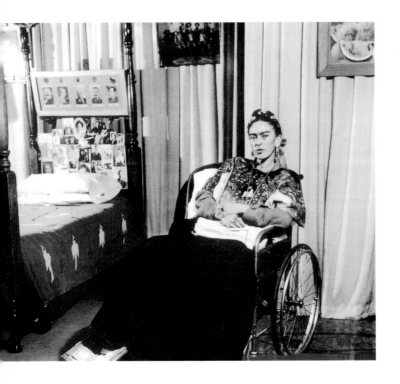

Because gangrene was spreading in her right leg, Kahlo's doctors decided in August 1953 that it had to be amputated below the knee. Kahlo acquiesced in their decision. 'Now it's a certain thing that they will amputate my right leg (...). I'm terrified and at the same time reason tells me that it will be a release. I only hope that, when I can walk again, I'll have enough strength left to live for Diego, everything for Diego!'[62] she wrote in her diary. Rivera remarked to a woman friend on the decision to amputate Kahlo's leg: 'She won't survive it, that'll be the end of her.'

Frightening drawings surfaced in her diary before she was operated on, revealing how terrified she was. Yet even now Frida Kahlo had not entirely lost her optimism, as one can see in a drawing with the feet cut off but with the poetic query 'why do I need feet when I have wings to fly' written under it. However, after her leg was amputated, Kahlo was never the same again. Rarely cheerful, she now grew even more aggressive and irritable to the detriment of old friendships. The touchiness that led her to pick quarrels was caused in some measure by drug addiction. Rivera even tried to replace her medication with alcohol. The outcome was that she drank two litres of cognac a day. 'After her leg was amputed,' reports Rivera in his auto- biography, 'Frida was in a deep depression. (...). She had lost all the joy in living.'[63] He had yet another new love, which drove Kahlo to another suicide attempt in despair. After not painting for months, she took up her brush again in the spring of 1954 to paint *Self-Portrait with Portrait of Diego on my Chest and María between my Eyebrows* and political pictures like *Marxism will Heal the Sick*. In Raquel Tibol's presence, Kahlo destroyed a late portrait,

pages 108–109:
The last pictures in Frida Kahlo's diary
(pp. 170 and 171)
1954
Mixed media on paper
Diego Rivera and Frida Kahlo Museum,
Mexico City

above:
Frida Kahlo in her bedroom, 1953.
Photo: Lola Alvarez Bravo. Galéria Juan Martin,
Mexico City

opposite page:
Frida Kahlo
Marxism with Heal the Sick
c. 1954
Oil on board
76 x 61 cm
Diego Rivera and Frida Kahlo Museum,
Mexico City

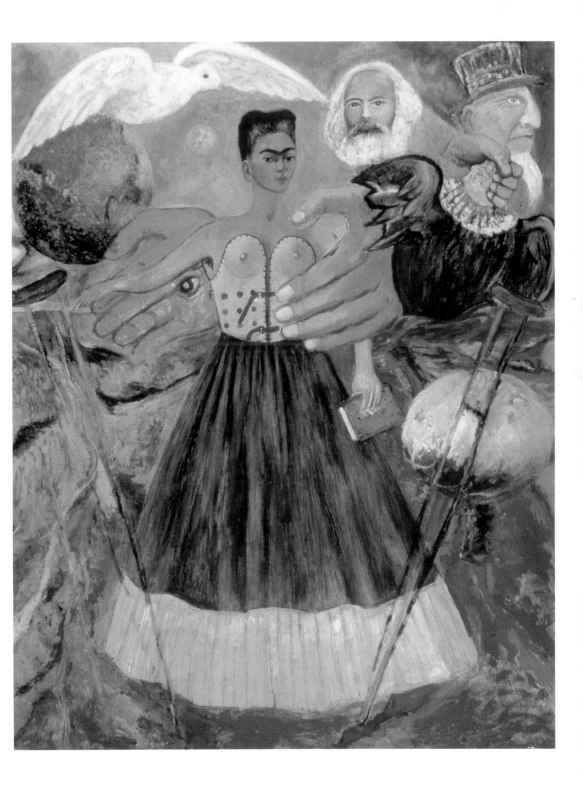

a painting in which her face was at the centre of a sunflower. Kahlo thought she looked as if she was choking in the flower. '(...) Everything was positive,' is how Tibol described the painting, 'it was radiantly seductive and emotional. Upset by the vitality emanating from her painting, which had deserted her in life, she seized a knife from Michoacán (...) and slowly began (...) to scratch up the painting, too slowly. With every scrape she was obliterating, destroying, herself as if in ritual self-sacrifice.'[64] In *The Brick Oven* Kahlo let herself be inspired to an imaginary excursion. The result is ominous, evocative of a crematorium. Kahlo wanted to be cremated.

On 2 July 1954, Frida Kahlo disobeyed her doctor's orders to accompany her husband to a solidarity demonstration for the government of Jacopo Arbenz in Guatemala. Too left-wing for the CIA, Arbenz had been overthrown with the connivance of that organization. This was to be Kahlo's last public appearance. A photo taken at the demonstration shows her greatly aged and frail. Rivera looks haggard, his face looks anxious. Kahlo had had pneumonia but it proved resistant to medication and soon recurred. She was near death. Her last words in her diary are: 'I hope that death will be easy and I hope I won't come back.'[65] Her last drawing is hauntingly apocalyptic. An angel wearing black boots floats heavenwards on green wings. As Rivera recalled their last hour together before she died: 'The evening before she had given me the ring she had bought for our silver wedding anniversary, which we would have celebrated in seventeen days. I asked why she was giving me the ring now and she replied, "because I sense that I'll be leaving you very soon."'[66]

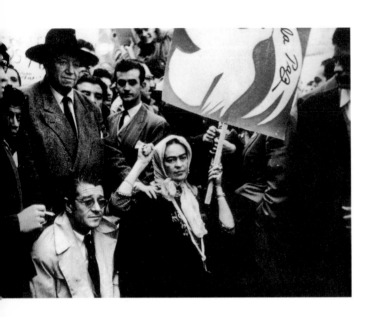

Frida Kahlo in her wheelchair at a demonstration against the deposition of the Guatemalan president, Jacobo Arbenz Guzmán by the CIA.
1954
Photo: With the kind permission of Excelsior

112

Frida Kahlo
Still life: Viva la Vida
c. 1951–54
Oil and earth on board
52 x 72 cm
Diego Rivera and Frida Kahlo Museum,
Mexico City

The night of 2 July 1954, Frida Kahlo died at the age of 47 in the Blue House. Pulmonary thrombosis was the cause of death on the certificate. If one reconsiders the last words in her diary, suicide is certainly a possibility although most of Kahlo's friends regard it as unlikely. The inscription on Kahlo's last painting, a still life with watermelons, reads like a hymn to life:

Viva la vida – Long live life

On the evening of 13 July, Frida Kahlo's body lay in state in the foyer of the Palacio de Bellas Artes, the most important Mexican cultural institution. She was dressed in her favourite Mexican dress, bright ribbons were woven into her hair and she wore lovely jewellery. Rivera, whose face suddenly looked sunken and grey, watched beside her the whole night. Somehow he refused to believe that his beloved Frida was dead. A friend of Kahlo's, the journalist Rosa Castro, re-

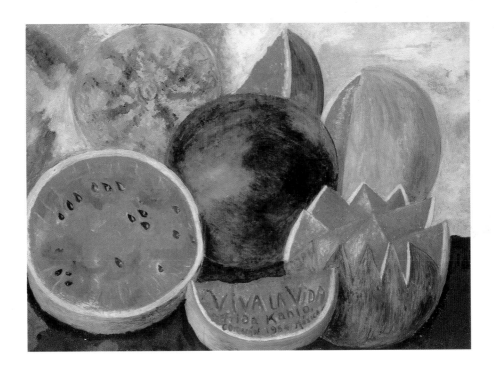

ported: 'When Frida was lying in state in Bellas Artes, Diego was standing with Dr. Frederico Marín. I went up to him and

asked: "What's wrong, Diego?" – "We're not entirely sure that she's really dead," was Diego's answer but Dr. Marín tried to intervene: "There's no doubt about it, Diego." – "Maybe," Diego answered, "but it's strange that she still shows signs of vascular movement. The hairs are standing up on her skin!" I can't stand the idea of her being cremated in such uncertain circumstances.' I said: "It's very simple. Let the doctor open her veins. If no blood flows, she's dead." So a cut was made and no blood came (...)'.[67]

Arturo García Bustos, one of the 'Los Fridos', draped her coffin with the communist flag, not the Mexican. The obsequies turned into a communist demonstration, shockingly close to a scandal. The director of the institute, who had been at school with Frida Kahlo, was suspended from office. Rivera, on the other hand, profited from the contretemps. On 26 September 1954 his fourth petition to be reinstated as a member of the Mexican Communist Party was granted.

By noon of the following day over 600 people had taken leave of Frida Kahlo. Then her coffin, surrounded by a sea of mourners, was carried in the rain to the crematorium of the municipal cemetery. The crowd packed into the hot little building, leaving many mourners outside. Rivera was beside himself with grief and wept openly. As the iron bier with Kahlo's body on it was shoved into the fire, a strange thing happened. Her body was lifted upright and, catching fire, her hair glowed like a wreath about her face, just as she had painted it at the centre of a sunflower in the picture she had deliberately destroyed. When the cart returned from the fire, Rivera made a sketch of her skeleton before pouring her ashes into a cloth. Frida Kahlo's ashes are kept in a pre-Columbian urn in the Blue House.

Diego without Frida

After Kahlo's death, Rivera despaired. He deeply mourned her and aged years overnight. 'The most tragic day of my life was 13 July 1954. I had lost my beloved Frida forever

(...); my only comfort was that I had been taken back into the communist party,'[68] wrote Rivera in his autobiography. He never ceased to venerate Frida as a person and an artist. 'Numerous critics in various countries have characterized Frida Kahlo's work as being the most vigorously rooted in Mexican folk art of all the Moderns. That's what I think, too,'[69] Rivera said to Raquel Tibol. He proudly emphasized her importance as a painter: 'Even if her pictures don't spread across vast surfaces like our murals, Frida Kahlo is still the most important Mexican artist because her intense and profound work equals ours in both quality and quantity; her work (...) represents one of the most powerful and truthful human documents of our times. It will be of inestimable value for future generations.'[70]

Rivera commemorated his wife on the first anniversary of her death by drawing a smiling portrait of her with the following dedication: 'For the star of my eyes, Fridita, who is still mine, 13 July 1955, Diego. It was a year ago today.'[71] For all his grief, Diego did not remain alone very long. He remarried on 29 July 1955. His new wife was the publisher, Emma Hurtado. Soon after the wedding, Rivera went to the USSR for cobalt treatment. As an ironical twist of fate would have it, Rivera was suffering from cancer of the prostate. Despite his uncertain health, he was active both in Moscow and back in Mexico, where he painted a series of sunsets. Three years after Frida Kahlo's death, Diego Rivera died of a heart attack on 24 November 1957 in his San Angel studio. He had wanted to be cremated and asked that his ashes be commingled with Frida's. However, his wish was not granted. The muralist was enshrined with great ceremony in the Rotonda de los hombres illustres with other celebrated fellow-countrymen at the Dolores municipal cemetery. Never really one in life, Frida Kahlo and Diego Rivera remained apart in death.

following pages:
After a major operation in 1953 to amputate her foot, Frida Kahlo was photographed by the Mayo brothers who, at that time, were well-known photojournalists. Kahlo is shown smoking a cigarette in the Casa Azul, dressed in a traditional Mazahua costume.
Photo: Mayo brothers, with the kind permission of C. Stellweg, New York

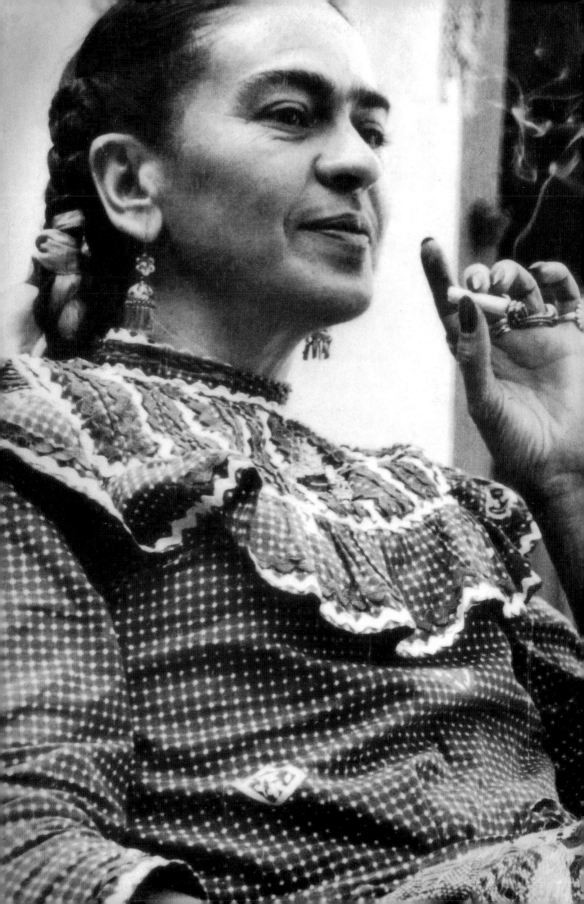

Endnotes

1. Herrera, Hayden: *Frida: A Biography of Frida Kahlo.* New York. 1983, p. 16
2. Ibid., p. 27
3. Ibid., p. 25
4. Ibid., p. 22
5. Ibid., p. 40
6. Jamis, Rauda: *Frida Kahlo. Malerin wider das Leiden.* Munich. 1991, p. 102
7. A word created by Frida Kahlo roughly equivalent to: 'very' or 'terribly'
8. Tibor, Raquel: *Frida Kahlo.* Frankfurt. 1980, pp. 27–32
9. Diego Rivera, *My Art, my Life, An Autobiography with Gladys March.* New York. 1991
10. Kettenmann, Andrea: *Diego Rivera. Ein revolutionärer Geist in der Kunst der Moderne.* Cologne. 1997, p. 23
11. Well-known artists of the Muralist movement in Mexico in the 20th century, whose work combined socialist and communist subjects with the history of Mexico, included Diego Rivera, José Clemente Orozco and David Alfaro Siqueiros
12. Suarez, Luis: *Diego Rivera: Confessions.* Berlin. 1966, p. 190
13. Herrera, Hayden: *Frida: A Biography of Frida Kahlo.* New York. 1983, pp. 73–4
14. Ibid., p. 74
15. Ibid., p. 77
16. Ibid., p. 84
17. Ibid., p. 86
18. Ibid., p. 90
19. Zamora, Martha: *Frida Kahlo. The Brush of Anguish.* 1990, p. 29
20. Herrera, Hayden: *Frida: A Biography of Frida Kahlo.* New York. 1983, p. 106
21. Ibid., p. 113
22. Ibid., pp. 125–6
23. Ibid., p. 155
24. Ibid., p. 166
25. Zamora, Martha: *Frida Kahlo. The Brush of Anguish.* 1999, p. 59
26. Breton, André: *Surrealism and Painting.* 1967, p. 149
27. Herrera, Hayden: *Frida Kahlo: A Life of Passion.* 1997, p. 186
28. Prignitz-Poda, Helga et al. (ed..): *Frida Kahlo. Oeuvre.* 1988, p. 244
29. Breton, André: *Surrealism and Painting. 1967,* p. 149
30. Herrera, Hayden: *Frida Kahlo: A Life of Passion.* 1997, p. 196
31. Ibid., p. 206
32. Ibid., p. 215
33. Ibid., p. 220
34. Tibor, Raquel: *Frida Kahlo.* Frankfurt. 1980, p. 84
35. Breton, André: *Surrealism and Painting.* 1967, p. 149f.
36. Bertram D. Wolfe, 'Rise of another Rivera', in: Vogue, 92, no. 1 (Oct./Nov. 1938), pp. 64, 131
37. Herrera, Hayden: *Frida Kahlo: A Life of Passion.* 1997, p. 238
38. Ibid., p. 239
39. Ibid., p. 249
40. Ibid., p. 165
41. Mulvey, Laura and Wollen, Peter: Frida Kahlo and Tina Modotti. Exhib. cat. London. 1982. p. 37. cf. Tibor, Raquel: *Frida Kahlo.* Frankfurt. 1980, p. 79
42. Herrera, Hayden: *Frida Kahlo: A Life of Passion.* 1997, p. 256
43. Ibid., p. 255
44. Herrera, Hayden: *Frida Kahlo. The Paintings.* Munich/Paris/London. 1992, p. 87
45. Ibid., p. 87
46. Herrera, Hayden: *Frida Kahlo: A Life of Passion.* 1997, p. 268
47. *Rivera, Diego: My Art, my Life. An Autobiography with Gladys March.* New York. 1991, p. 242f.
48. Tibor, Raquel: *Frida Kahlo.* Frankfurt. 1980, p. 109
49. Herrera, Hayden: *Frida Kahlo: A Life of Passion.* 1997, p. 249
50. Ibid., p. 250
51. Billeter, Eva (ed.): *Das Blaue Haus,. Die Welt der Frida Kahlo.* Frankfurt. 1993, p. 154
52. Herrera, Hayden: *Frida Kahlo: A Life of Passion.* 1997, p. 329
53. Suarez, Luis: *Diego Rivera: Confessions.* 1966, p. 16
54. *Frida Kahlo: An Illustrated Diary.* With an introduction by Carlos Fuentes: Commentary by Sarah M. Lowe. 1995, p. 205
55. Ibid., p. 235
56. 'Retrato de Diego'. In: *Diego Rivera. 50 anos de su labor artistica.* Exhib. cat. Mexico, 1951. p. 75f.
57. Herrera, Hayden: *Frida Kahlo: A Life of Passion.* 1997, p. 343
58. *Rivera, Diego: My Art, my Life. An Autobiography with Gladys March.* New York. 1991, p. 51
59. Ibid., p. 111
60. Herrera, Hayden: *Frida Kahlo: A Life of Passion.* 1997, p. 361
61. *Rivera, Diego: My Art, my Life. An Autobiography with Gladys March.* New York, p. 283f.
62. Herrera, Hayden: *Frida Kahlo: A Life of Passion.* 1997, pp. 373, 375
63. Herrera, Hayden: *Frida Kahlo: A Life of Passion.* 1997, p. 376
64. Tibor, Raquel: *Frida Kahlo.* Frankfurt. 1980, p. 11f..
65. *Frida Kahlo: An Illustrated Diary.* With an introduction by Carlos Fuentes: Commentary by Sarah M. Lowe.
66. *Rivera, Diego: My Art, my Life. An Autobiography with Gladys March.* New York. 1991, p. 285
67. Herrera, Hayden: *Frida Kahlo: A Life of Passion.* 1997, p. 394
68. *Rivera, Diego: My Art, my Life. An Autobiography with Gladys March.* New York. 1991, p. 285f.
69. Tibor, Raquel: *Frida Kahlo.* Frankfurt. 1980, p. 85
70. Ibid., p. 87
71. Le Clèzio, J.M.G.: *Diego and Rivera.* Munich. p. 229

Photographic Credits:

AKG Berlin: pages 38, 44 top, 50, 57, 68, 70 top, 78–80, 83–85, 89, 90

Rafael Doniz: pages 18, 23–27, 31, 32, 60, 64, 77, 87, 88, 98, 100, 111, 113

The illustrations from the diary of Frida Kahlo were taken from the volume *Frida Kahlo: Gemaltes Tagebuch*, Munich 1995: pages 6, 102–103, 106–107, 108–109 (originally published by Harry N. Abrams, Inc., New York

Musée National d'Art Moderne, Centre Georges Pompidou, Paris: page 63

Museum of Fine Arts, Boston: page 33

San Francisco Museum of Modern Art, San Francisco: page 37

Smith College Museum of Art, Northampton, Massachusetts: page 70, bottom

The Detroit Institute of Arts, Detroit: page 43

The Museum of Modern Art, New York: pages 9, 56, 72

All other photographic material has been taken from the archives of the Authors or the Publisher.

Front cover: Frida Kahlo, *Self-Portrait in a Velvet Dress*, 1926, Bequest of Alejandro Gómez Arias, Mexico City

Spine: Frida Kahlo, *Frida and Diego Rivera or Frida Kahlo and Diego Rivera*, detail (see page 37)

Frontispiece: Photograph of Frida Kahlo and Diego Rivera, *c.* 1954

Copyedited by Kate Garratt, Alston, GB

Library of Congress Catalog Card Number: 99-63854

© Prestel Verlag, Munich · London · New York, 1999

© of works illustrated by the Banco de Mexico, Fiduciario en el Fideicomiso relativo a los Museos Diego Rivera y Frida Kahlo, 1999

The Authors and the Publisher would like to thank HarperCollins*Publishers*, New York, and Bloomsbury Publishing, London, for their kind permission to reproduce extracts from: *Frida: A Critical Biography*, by Hayden Herrera

Prestel Verlag

Mandlstrasse 26 · 80802 Munich
Tel. (089) 381709-0, Fax (089) 381709-35;
16 West 22nd Street · New York, NY 10010
Tel. (212) 627-8199, Fax (212) 627-9866;
4 Bloomsbury Place · London WC1A 2QA
Tel. (0171) 323 5004, Fax (0171) 636 8004

Prestel books are available worldwide. Please contact your nearest bookseller or one of the above Presel offices for details concerning your local distributor:

Designed and typeset by WIGEL@xtras.de
Lithography by Repro Bayer, Munich
Printed and bound by Passavia Druckservice, Passau

Printed in Germany on acid-free paper
ISBN 3-7913-2164-1